IMAGES
of America
MARITIME
MILWAUKEE

On the Cover: The *Milwaukee Clipper* is seen here coming into Milwaukee. (Courtesy of the Wisconsin Marine Historical Society/Milwaukee Public Library.)

IMAGES of America
MARITIME MILWAUKEE

Wisconsin Marine Historical Society

Copyright © 2011 by Wisconsin Marine Historical Society
ISBN 978-0-7385-8309-9

Published by Arcadia Publishing
Charleston, South Carolina

Printed in the United States of America

Library of Congress Control Number: 2010938527

For all general information, please contact Arcadia Publishing:
Telephone 843-853-2070
Fax 843-853-0044
E-mail sales@arcadiapublishing.com
For customer service and orders:
Toll-Free 1-888-313-2665

Visit us on the Internet at www.arcadiapublishing.com

CONTENTS

Acknowledgments		6
Introduction		7
1.	The Beginnings, Port, and Fishermen	9
2.	The Inner Harbor	27
3.	The Outer Harbor	61
4.	Menomonee River and Adjacent Canals	85
5.	The Milwaukee River	99
6.	The Port of Milwaukee Today	117

Acknowledgments

This book could never have been created without access to the extensive vessel files, subject files, and photographs maintained by the Wisconsin Marine Historical Society and the Milwaukee Public Library, and I wish to express my thanks for their generous assistance. I would also like to thank Suzette Lopez, Virginia Schwartz, and Carolyn Colwell for their invaluable assistance in helping me locate and select the material used. I am indebted to the Milwaukee Public Library for the use of its scanner, copier, and its facilities in general. In addition, I thank Eric Reinelt, director of the Port of Milwaukee, for the collection of photographs that were donated to the library and the marine society, supplementing their already extensive supply. Many of them were clearly unavailable elsewhere. The photographs in the final chapter are my own, but like those in the rest of the book, they can be found in the Wisconsin Marine Historical Society/Milwaukee Public Library collection. Unless otherwise noted, all images are courtesy of the Wisconsin Marine Historical Society and the Milwaukee Public Library.

Although not a source for any of the photographs used here, John Gurda's 1999 book, *The Making of Milwaukee*, published by the Milwaukee County Historical Society, is the source of much of my knowledge of Milwaukee's history. It is the best on the subject that I have found. I recommend the book to those interested in seeking additional information about the history of Milwaukee and its waterways.

I would especially like to thank Jane Plowman and Rose Fortier for scanning all of the photographs and Suzette Lopez, Wisconsin Marine Historical Society executive director; Jack Godden, Wisconsin Marine Historical Society curator; and Jane Plowman for checking my text. Finally, I thank my fellow Wisconsin Marine Historical Society Tuesday volunteers at the library who took up the slack when I didn't have time to do my usual activities because I was "working on the book."

—Charles A. Sterba, editor

INTRODUCTION

The Port of Milwaukee has a past, a present, and a future. Like most Great Lakes ports, it developed at a river mouth that, due to sandbars constantly forming and reforming offshore, was not the perfect harbor as one might expect. The three rivers, Milwaukee, Menomonee, and Kinnickinnic, came together to form a common outlet into the lake. They opened the way for settlement, and human engineering immediately set about to fix what nature had left in an imperfect state, first by building piers and later by cutting, straightening, and deepening channels so that ships could visit and industry could grow.

By the mid-19th century, Milwaukee was the leading wheat shipping port on the Great Lakes. As the center of grain growing moved North and West, this forced a change in trade to other commodities. Milwaukee was blessed with a large steel mill, Illinois Steel Company, which brought in ships loaded with iron ore, coal, and limestone for that industry. Manufacturing grew with major companies like Allis-Chalmers, Harnischfeger, and many others that shipped their products around the world in vessels calling at the Port of Milwaukee.

In the early days, much of the industry was along the three rivers, with large freighters going far upstream to service their customers. With the growth of other modes of transportation, particularly rail and, more recently, with the advent of the internal combustion engine and the tremendous increase in trucking, ship traffic dropped off, and bridges became more important arteries of transport than the rivers they cross. Today only the Kinnickinnic and the inner harbor basin, which was developed from it, receive any significant vessel traffic. But while the rivers declined in the volume of trade they carried, the people of Milwaukee developed an outer harbor on Lake Michigan, through which goods could be moved without the ships having to pass deep into the city.

The Port of Milwaukee continues to receive coal for the production of electric power (Wisconsin Electric Company now WE Energies), while the Lafarge and St. Marys cement companies regularly receive and supply cement to most of Southern Wisconsin. Road salt too is a regular cargo brought in to the Port of Milwaukee from deposits in Canada and Michigan, with the port then supplying the needs of Southern Wisconsin and Northern Illinois. Grain is still shipped from the Nidera elevator, sometimes by ship (both fresh and saltwater) and frequently by barge. Finally, the outer harbor receives large quantities of steel produced abroad, which is then distributed by truck and rail to industry. Container traffic has become a big topic today, but the Port of Milwaukee has been involved in container shipping for over 30 years. In general, the amount of material passing through the port has increased year by year.

This book can offer only a brief look at what shipping was like in Milwaukee over the past 150 years. For a detailed history, one would have to look elsewhere. However, the photographs of the Milwaukee waterways contained herein do give a glimpse of what the port was like and how it evolved over the years. It is hoped that the reader will find them of great interest and will be motivated to turn to the Milwaukee Public Library and the Wisconsin Marine Historical Society for additional information.

One
THE BEGINNINGS, PORT, FISHERMEN

Milwaukee's first settlers were Native Americans, chiefly the Potawatomi, Ottawa, Ojibway, and Menominee; the Potawatomi was the dominant group. The rivers followed pretty much the same course as today, but their original outlet was at about the present Lincoln Avenue Viaduct. The rivers together with Lake Michigan constituted the Native American highways, and these continued to serve as the routes for the first commerce in the area. A schooner found shelter in the river mouth as early as 1778, but European settlement did not begin until after 1818, when Solomon Juneau established the first trading post in the area.

Jones Island was always a peninsula, but it was connected to the mainland at its north end, rather than at the south as it is today. Early on, piers were built at the natural harbor mouth, but the whole thing proved unsatisfactory. Most of the land surrounding the rivers, including Jones Island, was swamp. The Native Americans together with the earliest European settlers lived on the bluffs to the north and on higher ground to the west. They only visited Jones Island to fish, hunt, and to harvest the wild rice.

The harbor at the south end of Jones Island was inconvenient, and the earliest commercial pier in the lake was North Pier. It was built in 1842 at Huron Street, about where Discovery World is located today. A better solution, moving the river mouth closer to the settlement, was accomplished with the "straight cut" channel, which was completed in 1858 after four years of digging. Unfortunately few photographs exist from this early period. The straight cut opened the city to large ships and was really the start of the Port of Milwaukee. It remains, after 150 years, as today's harbor entrance.

The straight cut transformed Jones Island into a real island, which it remained until the original channel silted in. One of the earliest industries on the island was a shipyard that was begun by Capt. James Monroe Jones, the source of the island's name. Until ruined by the 1857 financial panic and the big storm of 1858, he built at least two dozen vessels on the island.

In the 1870s, fishermen from Kaszuby, part of Poland's Baltic coast, and Northern Germany settled on the island as squatters. They apparently never secured title to the land, continuing on with their pioneer style of life into the 1930s, when they were expelled, ostensibly "for their own good" but probably to allow industrial expansion of the port. Due in part to Dr. Ruth Kriehn's book, *The Fisher Folk of Jones Island,* today they remain popular in Milwaukee folk history.

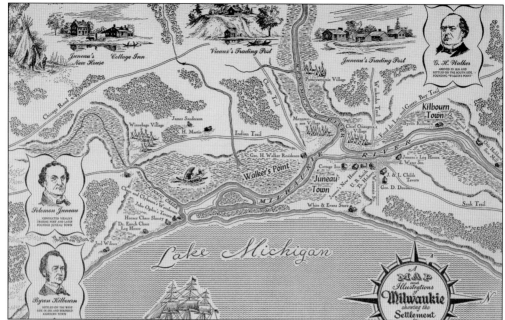

Here is a map of Milwaukee settlement in 1835. The mouth of the Milwaukee River is far to the south of its current location. There are no harbor piers and no straight cut and likewise no Jones Island. The small island in the river mouth was uninhabited. Pictured are the founders of the three communities that coalesced to form the city of Milwaukee, G. H. Walker (above left), Byron Kilbourn (below left), and Soloman Juneau (right). (Date of photograph: unidentified; photographer: Brown and Rehbaum.)

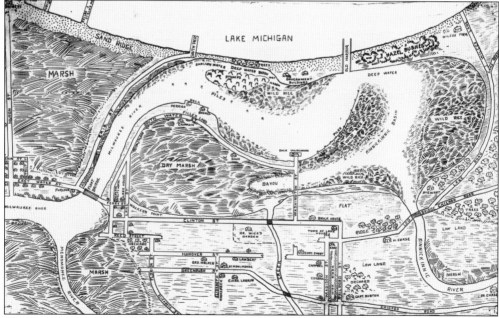

This map dates to around 1848. The port was served by two small piers and a dredged opening to the south at the original river mouth; it was improved, but not by much. Jones Island was still mostly given over to wild rice. (Date of photograph: unidentified; photographer: D. W. Chipman.)

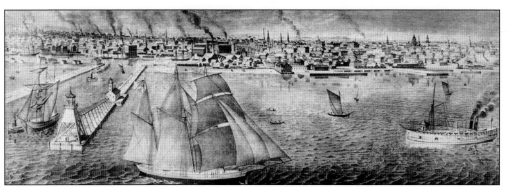

A lithograph shows the Port of Milwaukee around 1870, with piers adjoining the straight cut that lead into the confluence of the Milwaukee, Menomonee, and Kinnickinnic Rivers. Today most of the area landward of the ends of the piers is landfill. (Date of calendar: unidentified; photographer: unidentified.)

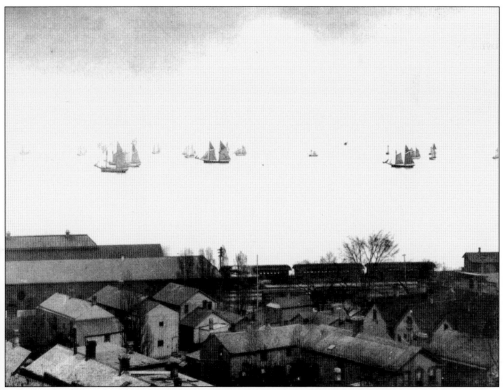

This is north of the harbor entrance around 1892. The railroad was already servicing the lakefront. Note that the outer harbor is filled with schooners, but there are no steamers in sight. (Date of photograph: *c.* 1892; photographer: unidentified.)

This view looking toward the lake, just north of the harbor entrance, shows the pier with a lighthouse, foghorn, and the Coast Guard station around 1900. A tug is towing in a schooner. (Date of photograph: unidentified; photographer: unidentified.)

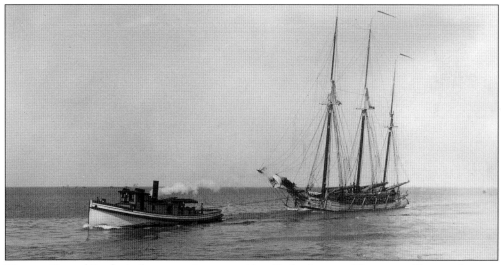

The tug *Conrad Starke* is shown towing an unidentified schooner. They are still somewhat out from the piers. (Date of photograph: early 1900s; photographer: Brown and Son.)

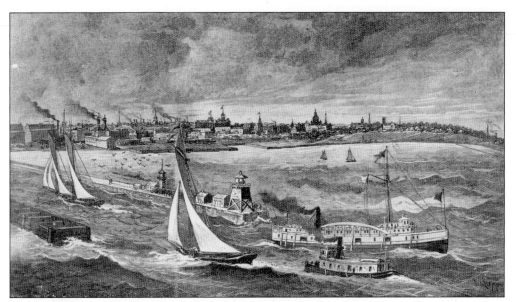

Vessels, including a passenger/package freight carrier with a hogging arch, are coming in and out between the piers, probably depicting heavier traffic than what really occurred. This is from the 1890s. (Date of photograph: unidentified; photographer: unidentified.)

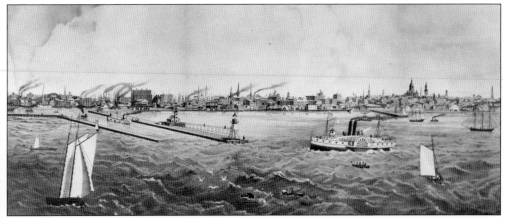

This is Jones Island around 1912. Not much has changed since the 1870s with piers projecting into the lake. Note the lighthouse and Coast Guard station are the same as in the 1870 lithograph. (Date of photograph: unidentified; photographer: unidentified.)

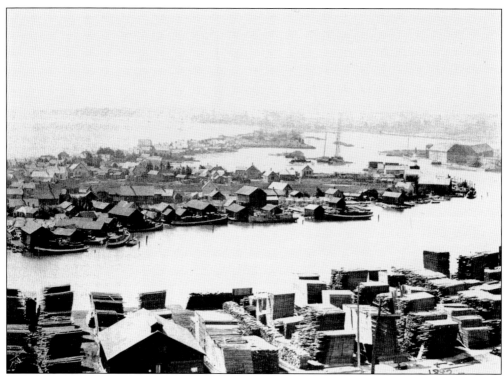

Here is Jones Island, around 1892, filled with the squatters' residences. The majority of the squatters came from Kaszuby, which is a region of coastal Poland near what once was the German border. On the near side of the channel is a lumberyard, adjacent to which was the Wolf and Davidson shipyard. (Date of photograph: unidentified; photographer: unidentified.)

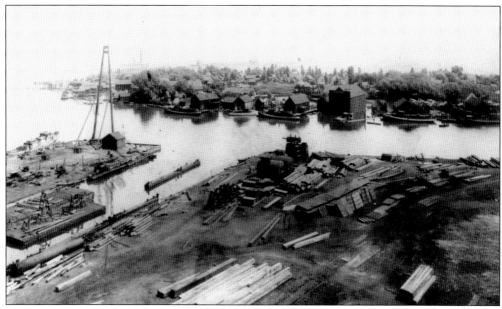

This image of Jones Island, from about 1892, shows the Wolf and Davidson shipyard with a slip for launching or repairing vessels. (Date of photograph: unidentified; photographer: unidentified.)

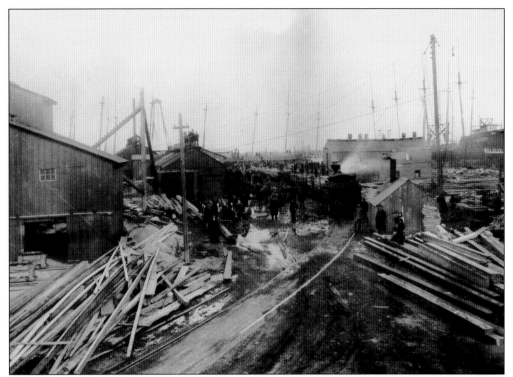

A locomotive is delivering a new supply of lumber to the Wolf and Davidson shipyard. Note the heavy timbers on the lower right and at the mouth of the shed on the left. There is a ship on the launch ways, just above the train. (Date of photograph: 1886; photographer: unidentified.)

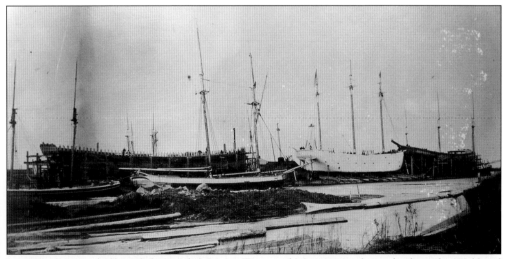

In 1873, the vessels (from left to right) *Itasca*, *Typo*, and *Marengo* are being built in the Wolf and Davidson shipyard, located off of the Kinnickinnic River, at the beginning of Washington Street and Vogel's Island. (Date of photograph: unidentified; photographer: unidentified.)

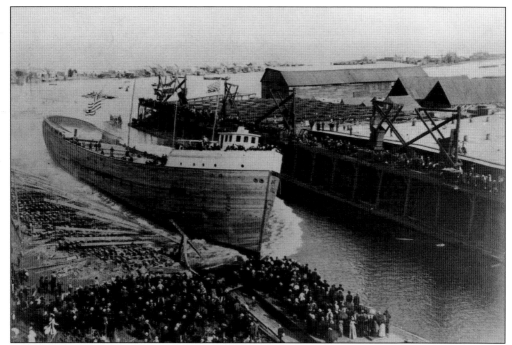

The launching of the steamer *William H. Wolf*, near the remains of the old coal docks at the Wolf and Davidson shipyard, is seen here on August 6, 1887. During the launch, two spectators died, and several others injured, when the vessel hit the water and threw up a great wall of water and spray that stuck the viewing stand, causing it to collapse. People were crushed and maimed by the fallen timbers and some were actually washed into the river. Launches were always a risky proposition and still are today, although they are much more controlled and monitored. (Date of photograph: unidentified; photographer: H. Hagen.)

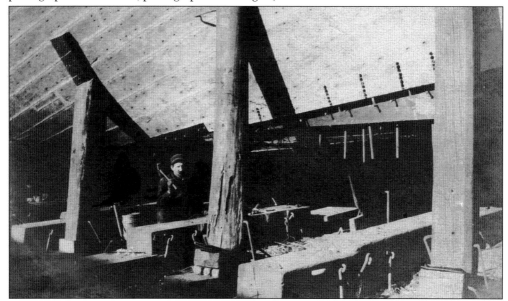

Workers repair a wooden steamer at the Washington Street shipyard around the late 1890s. (Date of photograph: unidentified; photographer: unidentified.)

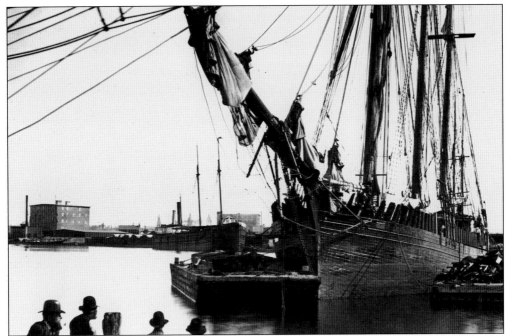

This is a view from the Wolf and Davidson shipyard from about 1880. The schooner is unidentified, but the steamer behind it is the *William H. Barnum*. (Date of photograph: unidentified; photographer: H. H. Bennett Studio.)

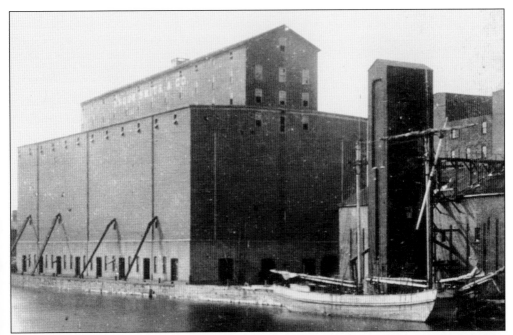

A schooner is tied up in front of a grain elevator, either near the mouth of the Milwaukee River or more likely further up on the Menomonee. (Date of photograph: c. 1890; photographer: unidentified.)

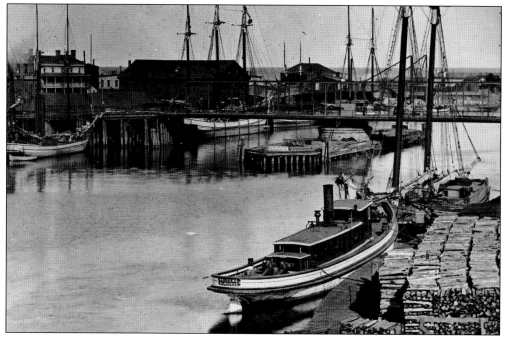

The tug *Welcome* is docked just south of Northwestern Railroad Bridge on the Milwaukee River about 1915; the other vessels are unidentified. The white building on he left is the Bethel Seaman's Home, located at the foot of Erie Street. (Date of photograph: unidentified; photographer: H. H. Bennett Studio.)

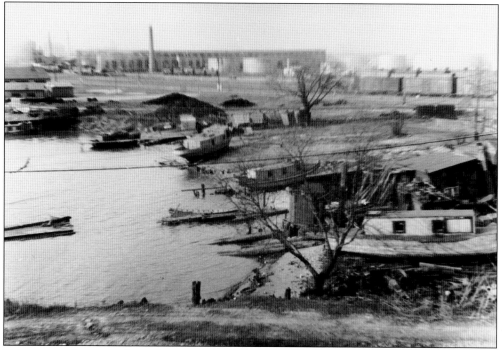

Fish tugs are drawn up along shore on Jones Island, and the Illinois Steel Company and railroad tracks are in the background. (Date of photograph: *c.* 1920; photographer: Ervin Reinelt.)

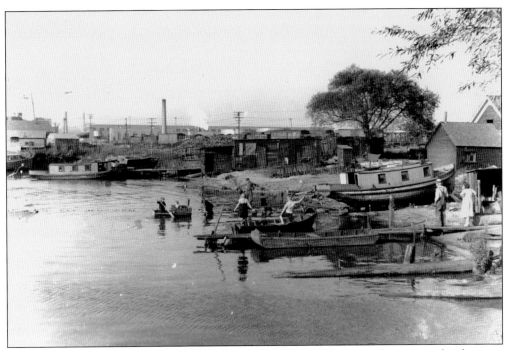

Here is a beached fish tug on Jones Island around 1920. Children are playing in other boats as adults watch. The Illinois Steel Company and railroad tracks are in the background. (Date of photograph: unidentified; photographer: Ervin Reinelt.)

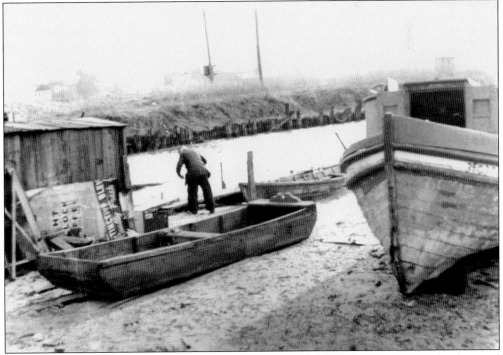

With a man doing some repairs, a flat-bottomed pram and a fish tug sit on Jones Island around 1920. (Date of photograph: unidentified; photographer: Ervin Reinelt.)

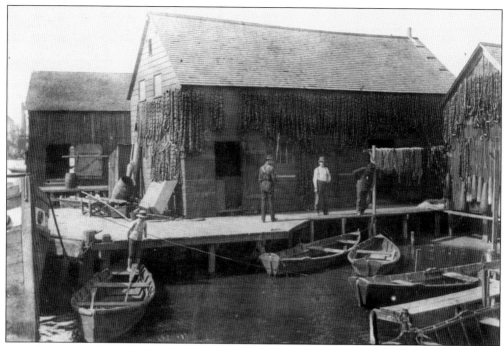

Nets drying on sheds and rowboats seen in this *c.* 1920 photograph made a typical sight in the Jones Island fishing community. (Date of photograph: unidentified; photographer: Ruth Kriehn.)

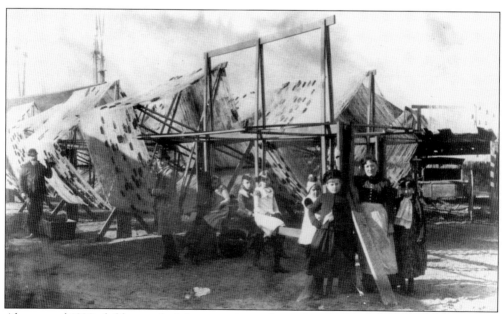

Also around 1920, children and adults are posing in front of net reels, while the nets dry, on Jones Island. (Date of photograph: unidentified; photographer: Ruth Kriehn.)

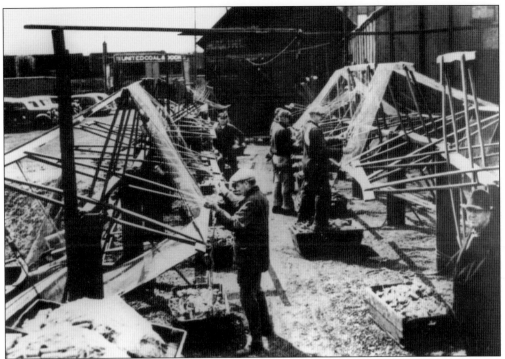
Here Jones Island men are shown mending nets on reels. Fish sheds can be seen in the background. (Date of photograph: c. 1920; photographer: Ruth Kriehn.)

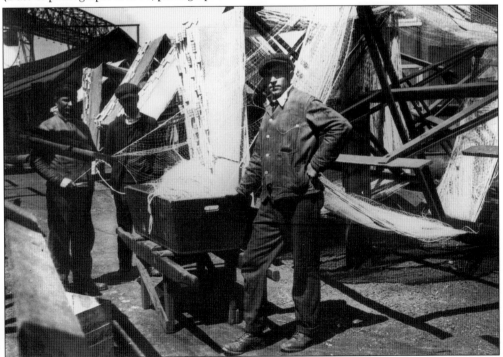
Fishermen are posing in front of nets on reels on Jones Island around 1920. (Date of photograph: unidentified; photographer: Ruth Kriehn.)

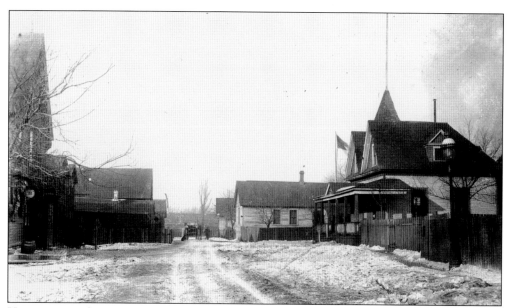
Here is a view of a street on Jones Island. (Date of photograph: unidentified; photographer: Kaiser.)

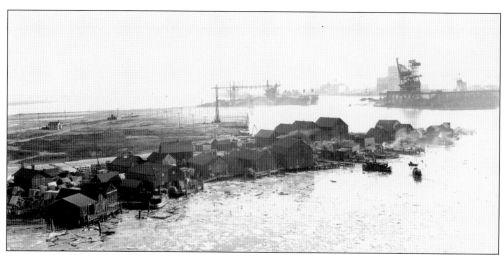
The south harbor tract, located on Jones Island, shows old fishing shacks and fish tugs. The Illinois Steel Company can be seen in background. (Date of photograph: 1922; photographer: unidentified.)

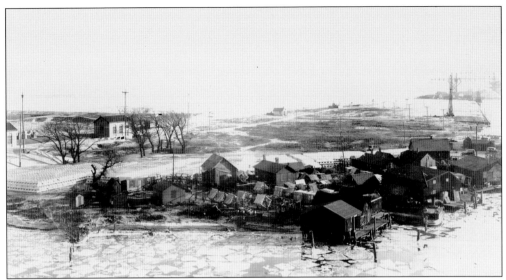

Here is a view of the Jones Island fishing settlement, looking southeast toward the lake. (Date of photograph: 1922; photographer: unidentified.)

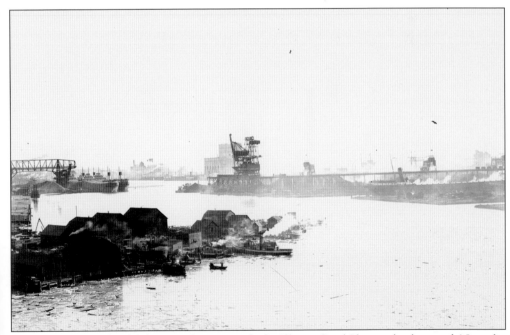

This is the Jones Island fishing settlement, with the Illinois Steel Plant in background. Note the modern freighters tied up at the far end of Kinnickinnic River. (Date of photograph: unidentified; photographer: unidentified.)

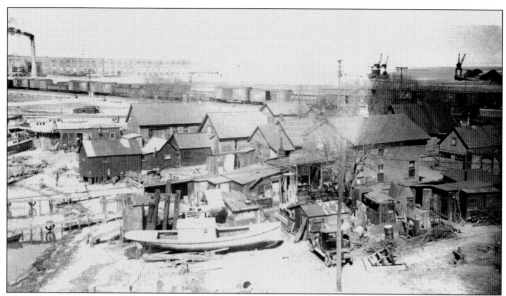

Here are the last vestiges of the Jones Island fishermen's settlement, looking east. The outer harbor is being developed, and trains are running the length of the island to the sanitation plant on the north end. (Date of photograph: unidentified; photographer: unidentified.)

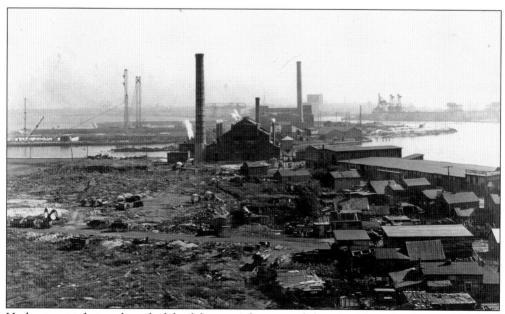

Harbor tract is being cleared of the fishermen's homes and shanties. Note the close proximity of the steel mills. (Date of photograph: unidentified; photographer: unidentified.)

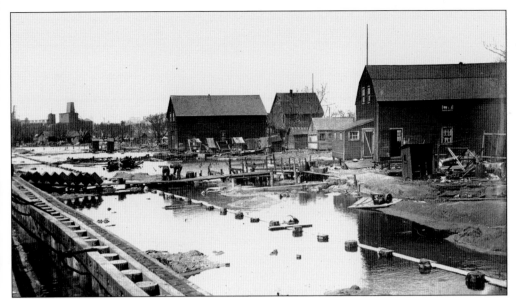

A revetment on Jones Island is shown prior to completion of the dredging and filling. This separated the fishermen from the water, and the buildings in the photograph were slated for removal. (Date of photograph: February 16, 1921; photographer: unidentified.)

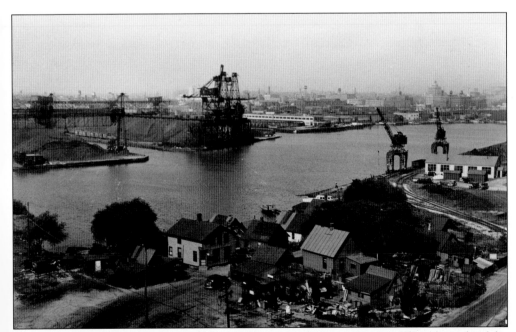

By the late 1930s, the fishing community on Jones Island was nearly gone. The other side of the basin was dominated by a large coal yard with huge bridge cranes, and even on the other side of the island heavy-lift cranes had replaced fish shanties and net reels. (Date of photograph: September 1938; photographer: unidentified.)

Presumably on a Great Lakes tour, this image is of a Viking ship entering the Port of Milwaukee. The ship was built for the World's Columbian Exposition of 1893 and sailed across the ocean from Norway for the fair. After having toured the Great Lakes, the ship ventured down the Mississippi River to New Orleans. (Date of photograph: unidentified; photographer: unidentified.)

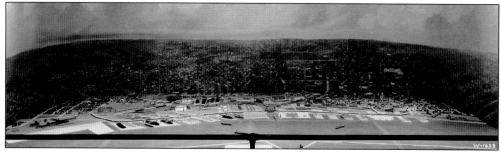

This image shows the Port of Milwaukee exhibit at the 1933 Century of Progress World's Fair in Chicago, Illinois. This was how Milwaukee's port was expected to develop. The piers north of the entrance channel were never built, but those piers to the south, the lakefront highway, and the bridge were built and are still part of Milwaukee's landscape today. (Date of photograph: June 1933; photographer: Kaufman-Fabry.)

Two
THE INNER HARBOR

The inner harbor is essentially a basin of the Kinnickinnic River, with Jones Island as its eastern shore. It is located where the waters of the Milwaukee, Menomonee, and Kinnickinnic Rivers originally combined, just as they were about to flow into the original and natural outlet to the lake. As a result, it is fairly broad and possesses water deep enough for big ships. Coal yards, a grain elevator, scrap yards, and petroleum farms grew up along the banks. Major shipping companies found it convenient to shelter their larger vessels here over the winter, which means these ships were protected from the high winds and waves on the lake. Three railroad car ferry companies had docks in the inner harbor, with the last one shutting down in 1981. The Interstate Commerce Commission authorized abandonment of the Chesapeake and Ohio's Milwaukee ferry route to begin in 1978, but various appeals kept the boats running. The last time Milwaukee appeared as a port of call for a car ferry was in a printed schedule dated September 8, 1981. The City of Milwaukee located its municipal dock and heavy-lift dock on the east side of the inner harbor.

The most significant industry was the Illinois Steel Company, situated due south of the inner harbor. It flourished from the latter part of the 19th century through the first quarter of the 20th century, but it failed to survive the Great Depression. Eventually its land and structures were sold to the City of Milwaukee for port development, and today little remains but some of the rail lines.

At the point where the inner harbor and harbor entrance channel meet, the city incinerator stood on the north side. To the south, the Milwaukee Metropolitan Sewerage District Plant is still located on the northern tip of Jones Island. Today most bulk cargos, chiefly of salt, cement, coal, and grain, go to or are shipped from docks in the inner harbor. Grain goes to the Nidera, formerly the Continental Grain, elevator. Manufactured goods are still loaded and unloaded at the heavy-lift dock.

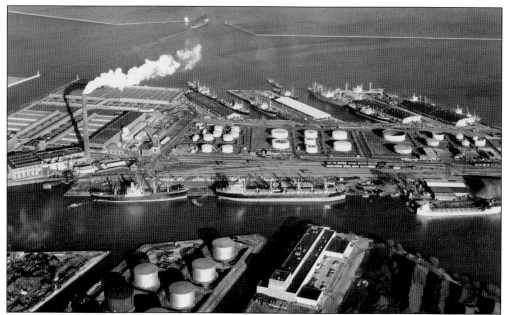

An aerial view of the south harbor tract, looking east, shows the inner and outer harbors, the sewerage treatment plant, the breakwater, and the lighthouses. Located between the oil tank farm and the coal yard is the site of the University of Wisconsin-Milwaukee's Great Lakes Water Institute. (Date of photograph: June 13, 1967; photographer: Clare J. Wilson.)

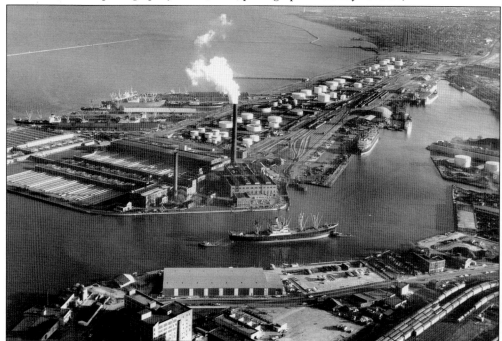

Taken for the Board of Harbor Commissioners, this aerial view of the south harbor tract shows an ocean-going vessel being towed backwards toward the lake. This view is looking southeast. In the foreground is the former Wolf and Davidson shipyard. (Date of photograph: November 13, 1967; photographer: Clare J. Wilson.)

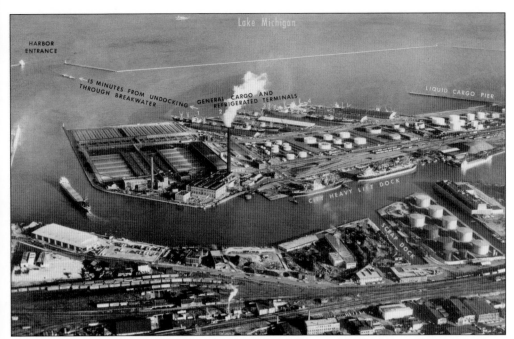

This aerial view of the south harbor tract indicates various port facilities. This was made as promotional material for the port director's trade mission to Europe in January 1970. (Date of photograph: November 13, 1967; photographer: Clare J. Wilson.)

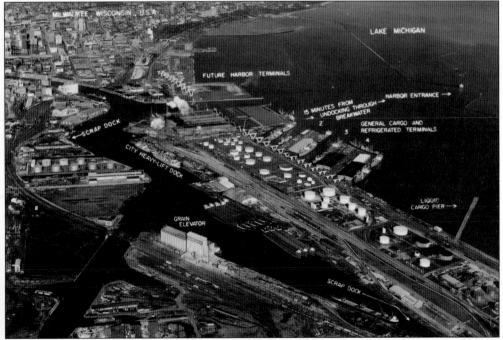

This aerial photograph is looking north, and the various port facilities are labeled. Interstate 794 and the Hoan Bridge are being built, as evidenced by the pillars along the outer harbor. Note that "Future Harbor Terminals" were never built. The site is occupied today by the Summerfest Grounds and the Lakeshore State Park. (Date of photograph: October 28, 1971; photographer: Clare J. Wilson.)

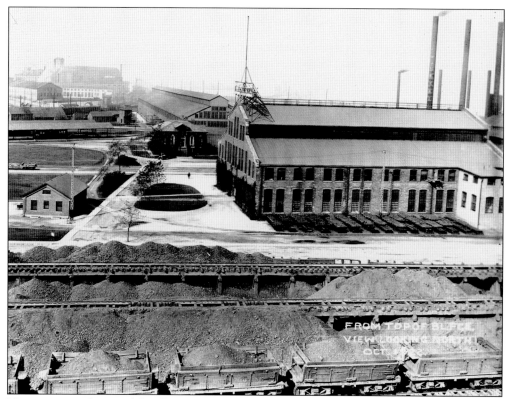

Here is a general view of the Illinois Steel Company's plant and buildings. (Date of photograph: October 1922; photographer: Illinois Steel Company.)

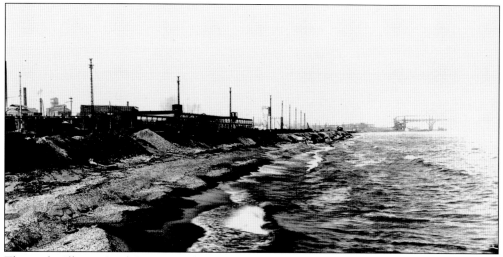

This is the Illinois Steel Company plant in the vicinity of the old billet yard, as seen from the lakeshore. Note the rough condition of the shoreline. Today the land around the eastern end of the Lincoln Avenue Viaduct and the Interstate 794 ramp is mostly vacant or is used for bulk-storage space. The port office and the *Lake Express* ferry dock occupy some of this land as well. (Date of photograph: October 1922; photographer: Illinois Steel Company.)

Looking southwest, this photograph is of the slip for the Illinois Steel Company, which is today's inner harbor. Note its much unimproved state. (Date of photograph: October 1922; photographer: Illinois Steel Company.)

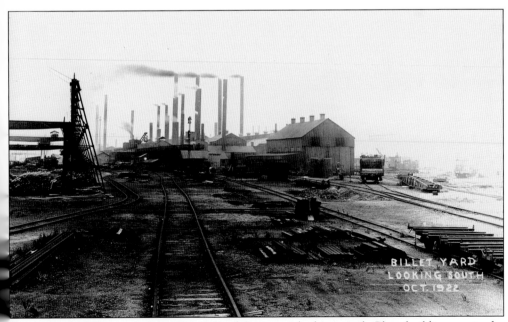

Pictured is the billet yard of the Illinois Steel Company, looking south. Plant buildings are in the background. (Date of photograph: October 1922; photographer: Illinois Steel Company.)

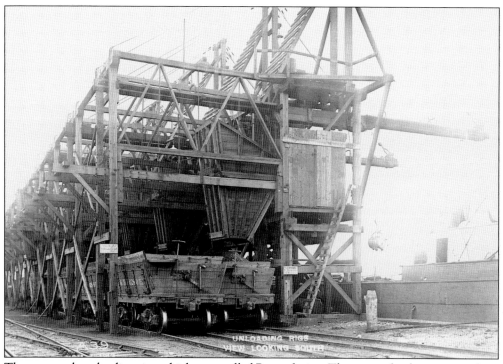

These are early unloading rigs, which were called Brown hoists. They are unloading iron ore from vessels and placing it into ore jennies to be hauled to the mill. (Date of photograph: November 4, 1913; photographer: Illinois Steel Company.)

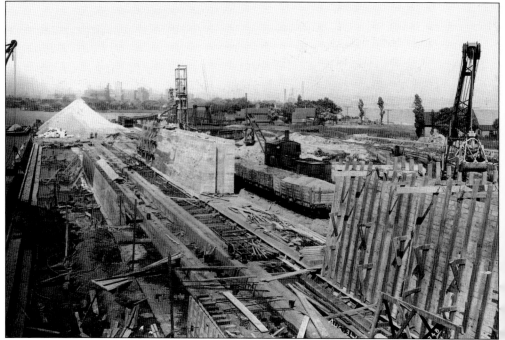

In this photograph, the Illinois Steel Company is laying the foundations for a bridge crane for vessel unloading. (Date of photograph: August 31, 1917; photographer: Illinois Steel Company.)

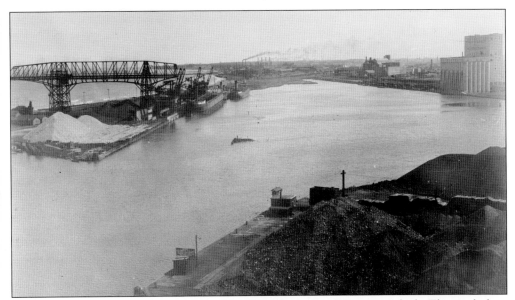

Vessels are tied up under the bridge crane at the Illinois Steel Company dock. The steel plant is seen in the distance. Note the island in the middle of the basin, which was later removed to facilitate navigation. At the extreme top right is the grain elevator. (Date of photograph: c. 1922; photographer: unidentified.)

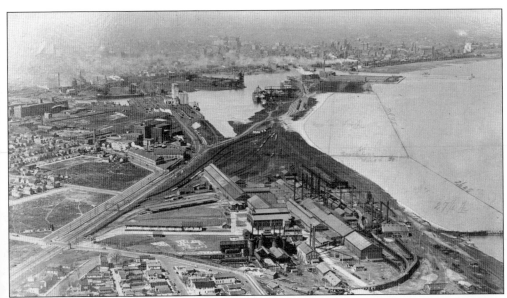

This aerial view of the Illinois Steel Company shows the large acreage involved. The picture is looking north, with the Milwaukee skyline at the top. Note the extensive rail yard and docks. At the extreme lower left is the corner tower of the famous Three Brothers Restaurant. (Date of photograph: June 1930; photographer: Kaiser.)

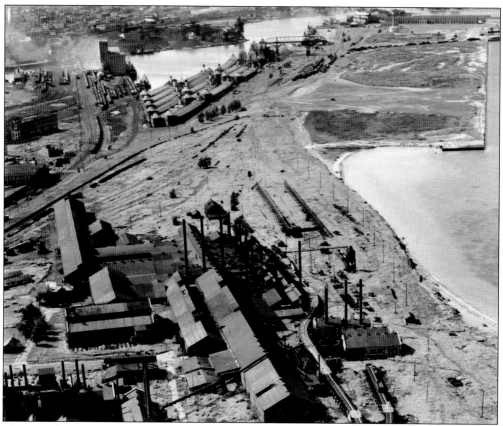

This aerial view of the Illinois Steel Company shows the plant and property, the south harbor tract, and the inner harbor basin. (Date of photograph: 1938; photographer: unidentified.)

Looking east, this photograph shows ships (including the *R. R. Richardson* and *Martian*) in the Illinois Steel Company slip. Note the bridge cranes on the left. (Date of photograph: April 5, 1926; photographer: Illinois Steel Company.)

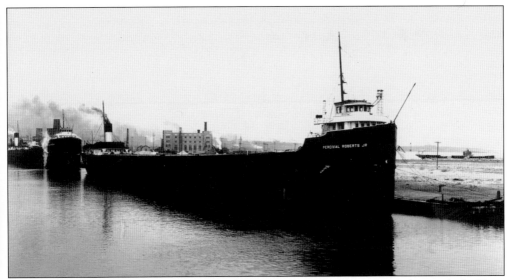

Along with other vessels, the SS *Percival Roberts Jr.* is moored at the municipal open dock. (Date of photograph: May 1, 1923; photographer: unidentified.)

This is the inner harbor basin of Kinnickinnic River, looking north. A bridge crane and vessels are seen at the Milwaukee Solvay Coke Company and United Coal and Dock Company facilities. (Date of photograph: May 1, 1923; photographer: unidentified.)

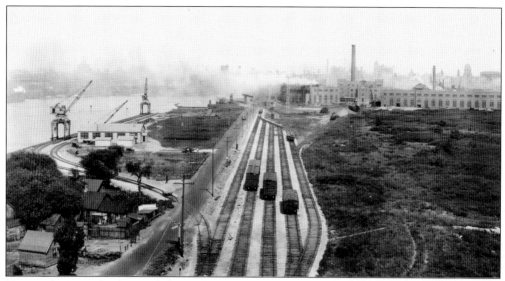

Here is the inner harbor with heavy-lift cranes. The sewerage plant and rail connections are visible on the right. (Date of photograph: 1931; photographer: Brown and Rehbaum.)

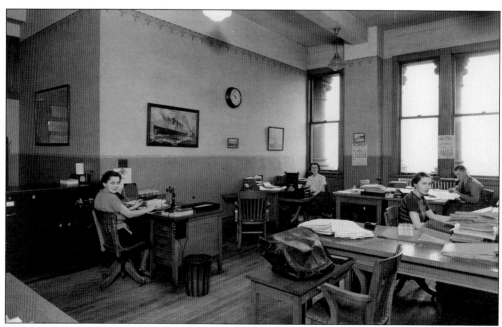

Here are the Board of Harbor Commissioners staff members in their office in city hall. The board operated out of city hall for many years until a port office was built near the harbor. (Date of photograph: February 1937; photographer: Enoch Falk.)

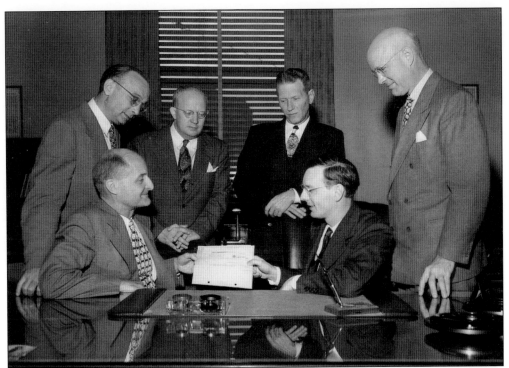

This documents the final payment made by the City of Milwaukee to the Illinois Steel Company for the purchase of its property for the development of the harbor. The men pictured are, from left to right, John J. Dolan, assistant city attorney; H. G. Irons, secretary and treasurer of Illinois Steel Company; Harry C. Brockel, municipal port director; V. H. Hurless, deputy city comptroller; Frank Zeidler, mayor; and R. C. Stephenson, general counsel member for Illinois Steel Company. (Date of photograph: July 23, 1948; photographer: Board of Harbor Commissioners.)

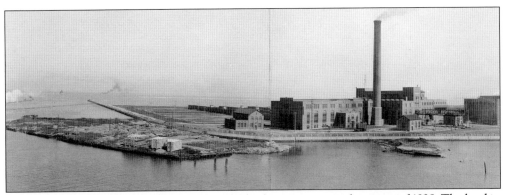

This photograph, looking southeast, shows the harbor entrance in the spring of 1928. The land in the foreground, located in front of the sewerage treatment plant, was later removed to straighten the harbor entrance. (Date of photograph: April 17, 1928; photographer: unidentified.)

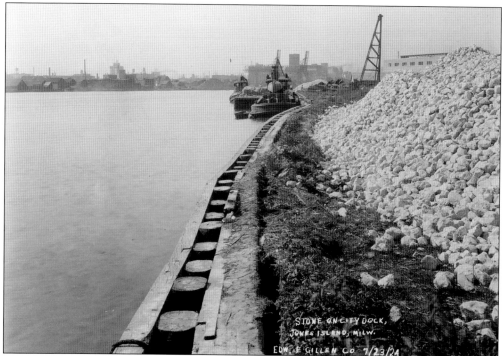

Stone is piled on the Municipal Open Dock for use in construction of the breakwater. Note the wooden construction of the dock wall, which was subject to rot and decay. (Date of photograph: July 23, 1924; photographer: Edward E. Gillen Company.)

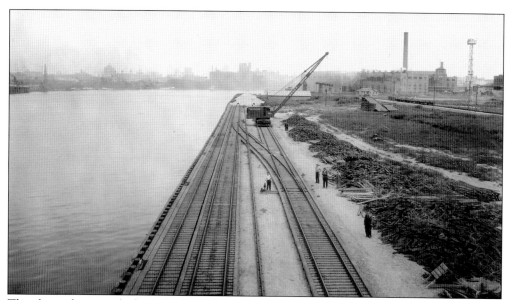

This shows the open dock tracks along the east shore of the inner harbor. The piles on the right are pig iron in storage. The Pere Marquette car ferry dock is visible just to the north. (Date of photograph: 1930; photographer: Brown and Rehbaum.)

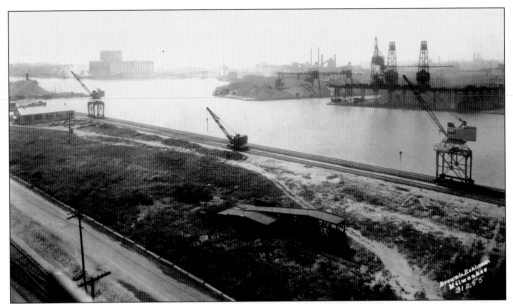

Here is the open dock terminal, looking southwest. The coal companies are across the basin, and the elevator is to the upper left. (Date of photograph: 1930; photographer: Brown and Rehbaum.)

This early photograph of the municipal mooring basin looks north. The photograph was taken before dredging and construction of the new metal dock wall. (Date of photograph: unidentified, photographer: George S. Carney.)

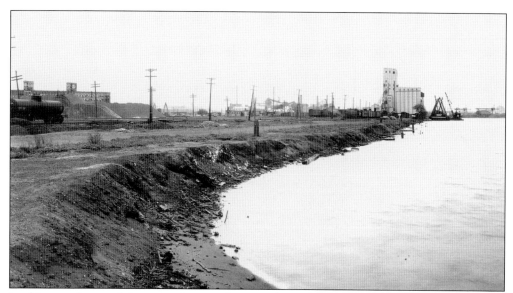

Looking north toward the grain elevator, this view shows the condition of the dock and frontage property of the west bank of the Kinnickinnic Basin. Before the new dock wall, the entire basin had a similar appearance. (Date of photograph: May 7, 1946; photographer: unidentified.)

An Edward E. Gillen Company dredge is busy in the mooring basin. (Date of photograph: November 4, 1931; photographer: Brown and Rehbaum.)

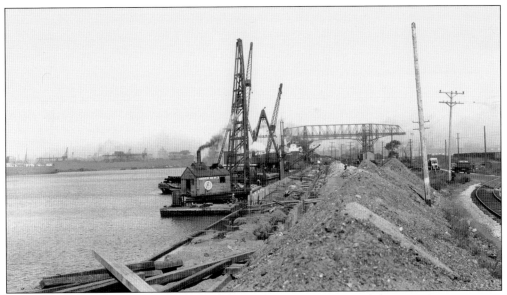

The Great Lakes Dredge and Dock Company is busy excavating and driving pilings to create 1,950 lineal feet of steel bulkhead to improve the shore facilities in the inner harbor. (Date of photograph: September 30, 1932; photographer: Breitwish.)

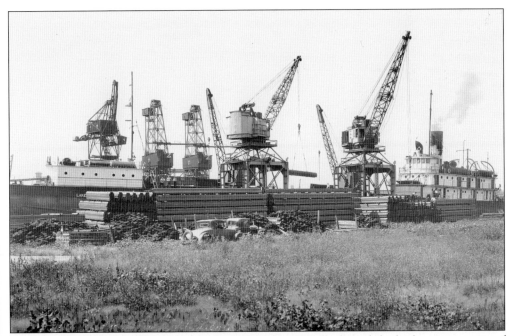

The whaleback freighter *Henry Cort* is docked in the inner harbor while discharging a cargo of sheet piling. (Date of photograph: 1931; photographer: Brown and Rehbaum.)

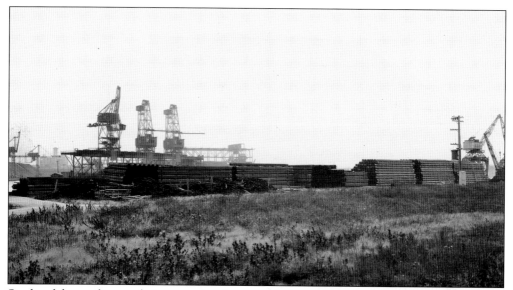

Stacks of sheet piling are being stored at the open dock terminal for use in the improvement of the shoreline of the inner harbor. (Date of photograph: October 14, 1931; photographer: Brown and Rehbaum.)

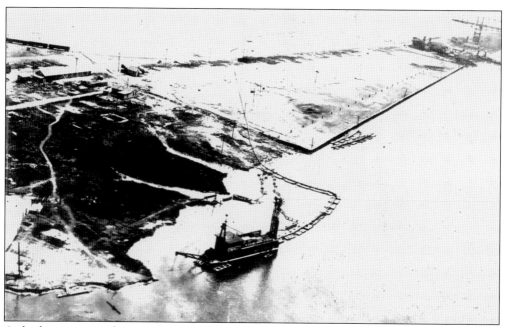

A dredge is engaged in operations in the Municipal Mooring Basin. Note that dredging spoils are being pumped to the outer harbor as landfill. (Date of photograph: unidentified; photographer: unidentified.)

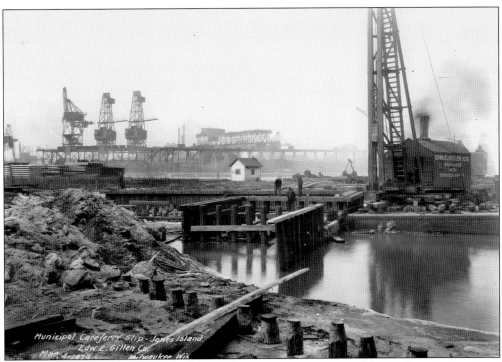

The Municipal Car Ferry Dock is under construction in this photograph. Timber is being placed on a casting chair. (Date of photograph: March 4, 1929; photographer: Brown and Rehbaum.)

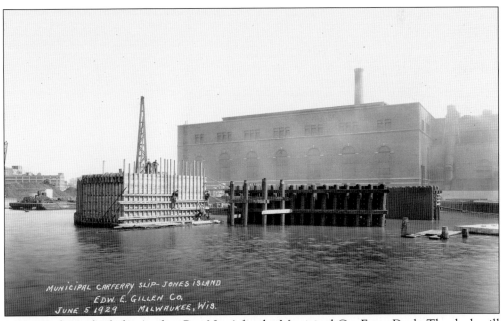

Forms are being built for Anchor Pier No. 1 for the Municipal Car Ferry Dock. The dock will be between the pilings on the right. (Date of photograph: June 5, 1929; photographer: Brown and Rehbaum.)

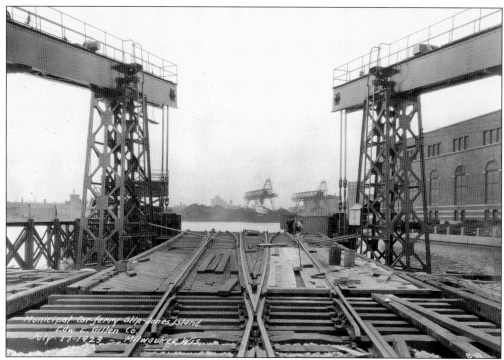

The Municipal Car Ferry slip on Jones Island features a transfer bridge, trackage, and towers. (Date of photograph: July 17, 1929; photographer: Brown and Rehbaum.)

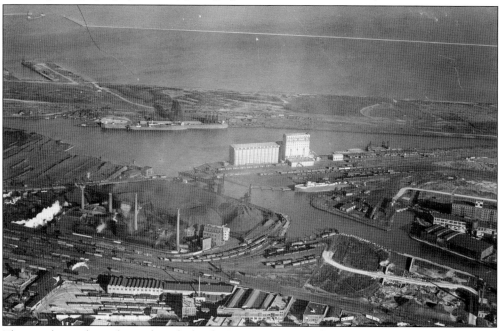

This aerial view shows the car ferry docks: the Pere Marquette at the Municipal Dock to the upper left and the Grand Trunk dock just below the grain elevator. Much has changed since this photograph was taken. Today's Barnacle Bud's Restaurant and the St. Marys Cement dock are located just to the right in this picture. (Date of photograph: November 1936; photographer: Midwest Airways, Inc.)

The car ferry *Pere Marquette 21* sits at the Municipal Car Ferry slip. (Date of photograph: prior to 1938; photographer: Brown and Rehbaum.)

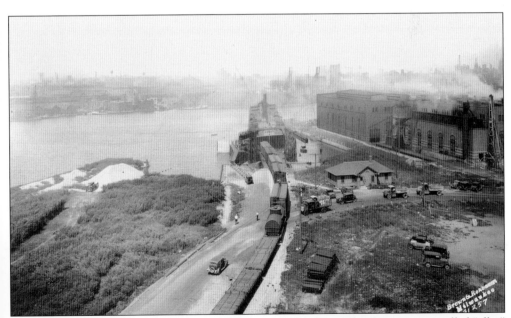

A train of freight cars is being loaded aboard a waiting car ferry. The flat cars were called "idler" flats. They were used between the cars being loaded and the locomotive to keep the weight of the engine from damaging the ferry ramp. Note the many trucks and cars waiting for the train to pass. (Date of photograph: c. 1930; photographer: Brown and Rehbaum.)

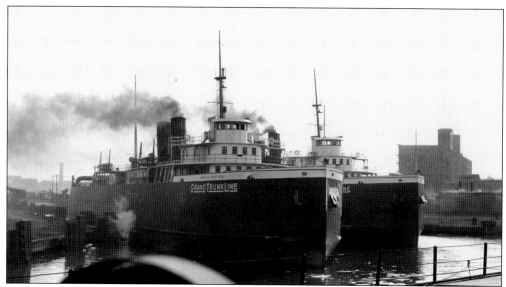

Two Grand Trunk Railroad car ferries (the one on the left is the *Grand Rapids*) wait at their dock further up the Kinnickinnic River. The slip is on the east side of the channel of the Kinnickinnic and not readily visible from Lincoln or Kinnickinnic Avenues. (Date of photograph: unidentified; photographer: Julius Fanta.)

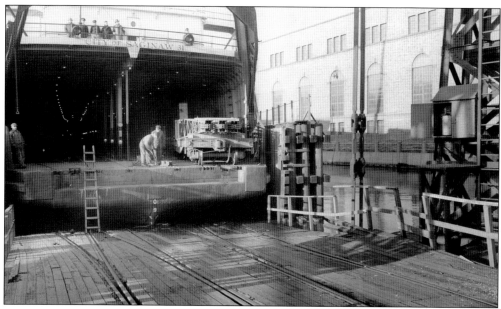

Accidents happen, as in this case at the Municipal Car Ferry Dock. The ferry *City of Saginaw 31* has ridden up on the transfer bridge, causing damage. (Date of photograph: December 3, 1943; photographer: Brown and Rehbaum.)

The Pere Marquette ferry *City of Saginaw* 31 waits at her dock, as a freighter unloads a cargo of coal across the basin. (Date of photograph: June 7, 1944; photographer: Brown and Rehbaum.)

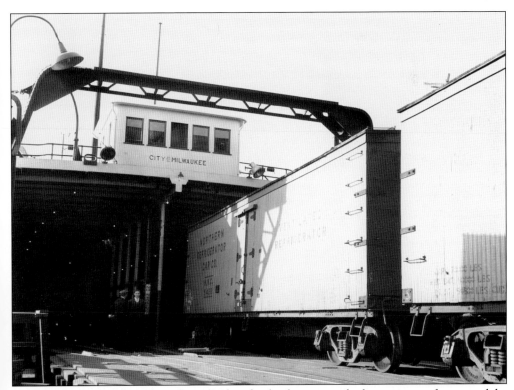

Here the Grand Trunk car ferry *City of Milwaukee* loads a string of refrigerator cars for a cross-lake run. (Date of photograph: unidentified; photographer: Julius Fanta.)

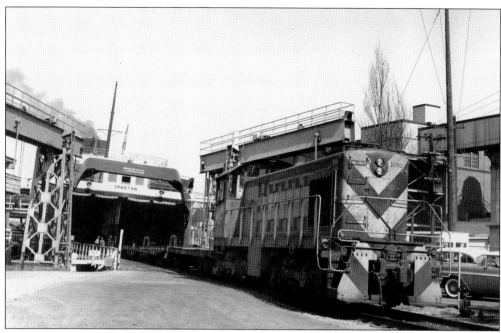

A Chicago Northwestern switcher completes loading a string of cars on the ferry *Spartan*. Note again the "idler" flatcars, which prevent the locomotive from going on the transfer bridge and damaging it. (Date of photograph: September 1957; photographer: Cramer-Krasselt.)

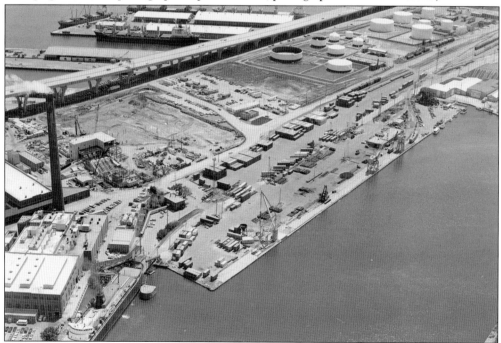

Railcar ferries continued to service the Port of Milwaukee until fairly recently. This shows the *Badger* at her slip, located next to the sewerage treatment plant, on July 19, 1984. The Interstate 794 expressway is visible between the inner and outer harbors. (Date of photograph: July 19, 1984; photographer: Robert T. McCoy.)

The heavy-lift cranes at the Municipal Open Dock frame some of the U.S. Steel vessels laid up in the Port of Milwaukee. For many years, Milwaukee was the lay-up and wintering site for the U.S. Steel fleet. (Date of photograph: May 1968; photographer: T. Stocki.)

This early photograph shows vessels of the Pittsburgh Steamship Company, later U.S. Steel, fleet laid up for the winter. The view is looking to the southeast. (Date of photograph: unidentified; photographer: Brown and Rehbaum.)

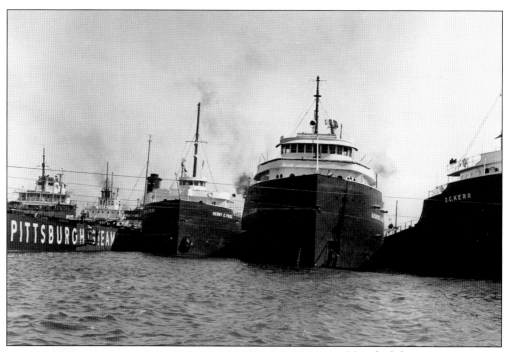

Vessels did not just stay in Milwaukee over winters, they also laid up there when they could not sail for other reasons. The U.S. Steel boats *Henry C. Frick*, *George A. Sloan* (today *Mississagi*), and *D. G. Kerr* are waiting for the 1952 steel strike to end. (Date of photograph: 1952; photographer: John S. Blank.)

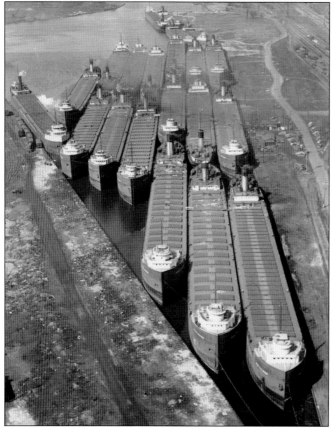

Here the U.S. Steel fleet is moored, packed like sardines, for the winter of 1948–1949. (Date of photograph: December 1948; photographer: unidentified.)

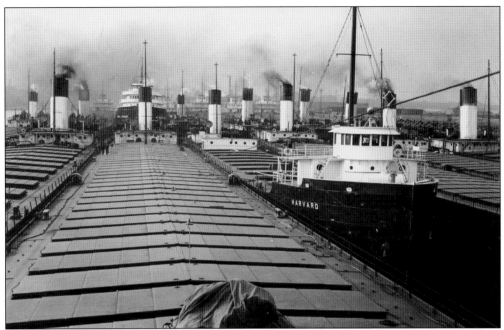

In this photograph, one can see just how closely these lake freighters of the U.S. Steel fleet are moored to each other. (Date of photograph: unidentified; photographer: Julius Fanta.)

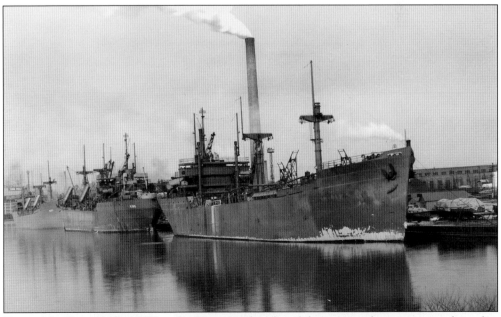

During the Second World War, the Port of Milwaukee did its part to keep troops and supplies moving. Here a group of new Maritime Commission merchant vessels is being outfitted for ocean service. (Date of photograph: January 26, 1945; photographer: Brown and Rehbaum.)

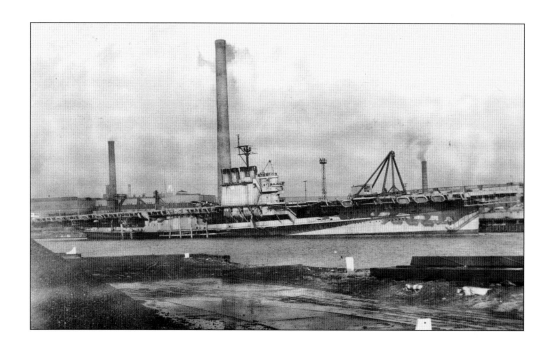

The passenger vessel *Seeandbee* had been converted to a training aircraft carrier, which was called the *Wolverine*. After the war, she was dismantled in Milwaukee's inner harbor. These two photographs show how quickly the vessel was taken apart. (Above, date of photograph: December 14, 1947; photographer: Dr. Lewis A. Buttles. Below, date of photograph: January 7, 1948; photographer: Dr. Lewis A. Buttles.)

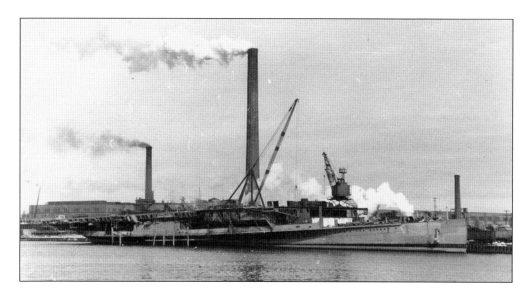

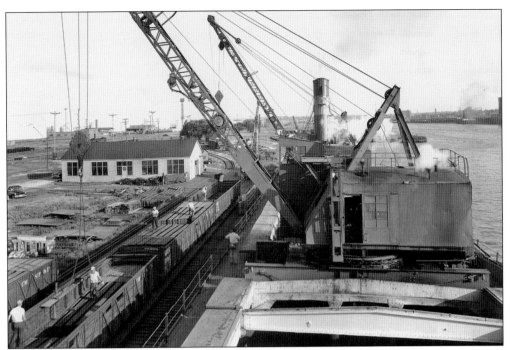

Crane ship *Harry T. Ewig* has tied up at the Municipal Open Dock and is loading structural steel from rail cars with its own cranes. (Date of photograph: August 1950; photographer: Wisconsin Bridge and Iron Company.)

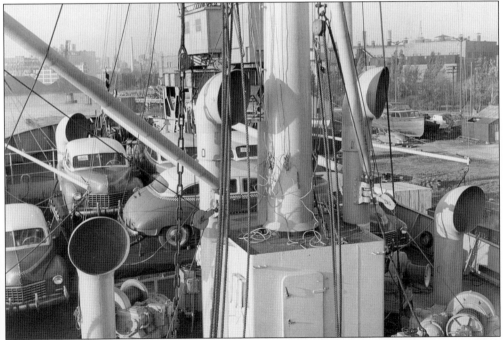

Old Chicago taxicabs are being loaded on a Fjell Line (Norwegian) freighter for export to Finland. They were one of the many products exported to Europe, which was still recovering from the Second World War. (Date of photograph: 1952; photographer: John S. Blank.)

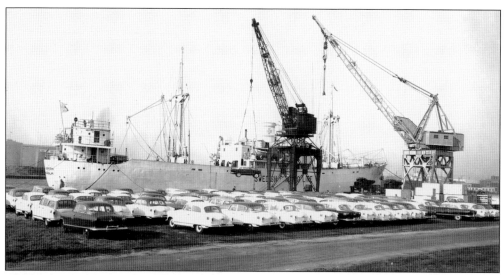

The freighter *Monica Smith*, of the Swedish Chicago Line, receives a cargo of new Nash automobiles for export to Europe. Also awaiting shipment are the other new cars stored in the foreground. (Date of photograph: November 1954; photographer: Brown and Rehbaum.)

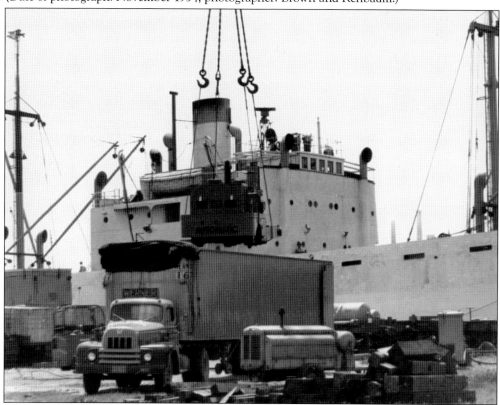

The heavy-lift crane is hoisting a load of machinery from a truck to the hold of a cargo vessel at the Municipal Open Dock. Such truck-to-ship transfers were common and played a major role in the shipping of industrial machinery in the 1950s. (Date of photograph: June 1955; photographer: Board of Harbor Commissioners.)

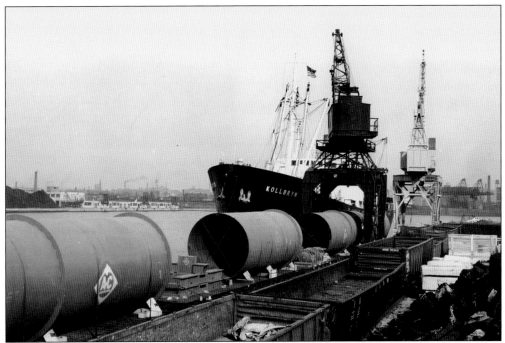

A heavy-lift crane loads an Allis-Chalmers cement mill on board the SS *Kollbryn* at the Municipal Open Dock terminal. (Date of photograph: September 9, 1955; photographer: Allis-Chalmers.)

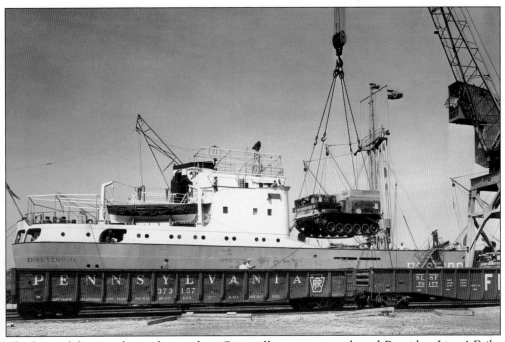

The heavy-lift crane hoists heavy-duty Caterpillar tractors on board Poseidon Lines' *Erika Schulte*. Pennsylvania Railroad and Frisco Railroad gondola cars occupy the foreground. (Date of photograph: July 2, 1957; photographer: Brown and Rehbaum.)

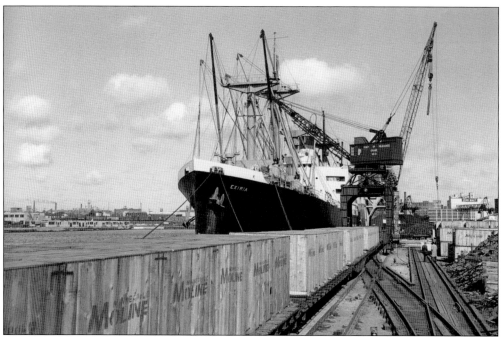

Minneapolis-Moline tractors are being loaded on American Export Lines' *Exiria* from rail cars at the Municipal Open Dock. (Date of photograph: September 17, 1959; photographer: Clair J. Wilson.)

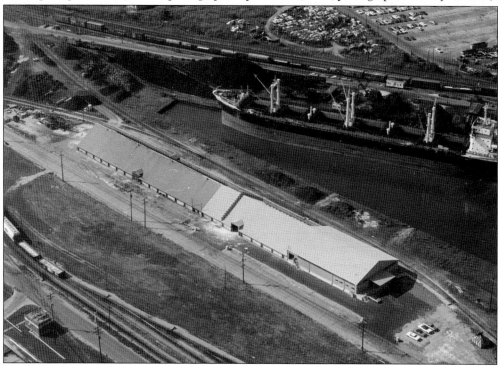

An aerial view of the International Salt Company warehouse is in the foreground, with M/V *Olympic Pride* docked at Miller Compressing on the far side. (Date of photograph: September 15, 1969; photographer: International Salt Company.)

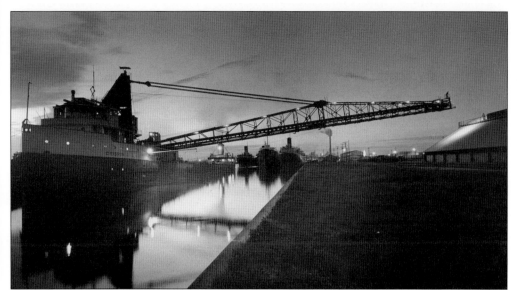

Self-unloader *Crispin Oglebay* discharges a load of salt into the International Salt Company's warehouse just after sunset. Salt remains an important cargo for the Port of Milwaukee. (Date of photograph: *c.* 1962; photographer: George Marshall.)

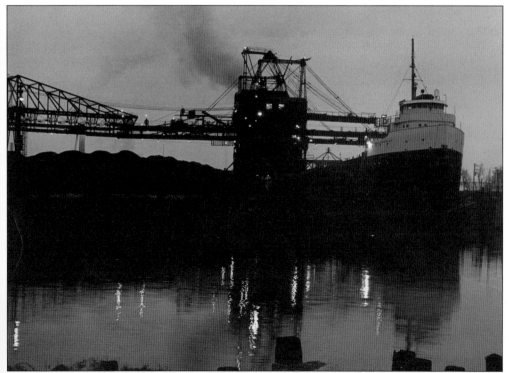

A bridge crane unloads coal at the Milwaukee Solvay Coke Company from the lake freighter *William H. Wolf*. As self-unloaders became more common, the need for bridge cranes has declined to the point that none remain in the Milwaukee Harbor. (Date of photograph: *c.* 1974; photographer: George Marshall.)

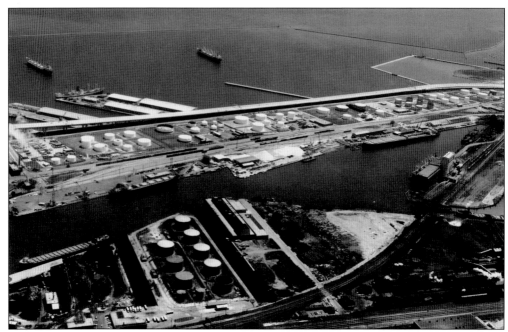

The 1,000-foot *Presque Isle* tug/barge is at Advance Boiler awaiting repairs. There is an unidentified saltwater vessel at the grain elevator, and others are waiting their turn inside the breakwater in the outer harbor. (Date of photograph: June 15, 1978; photographer: Clair J. Wilson.)

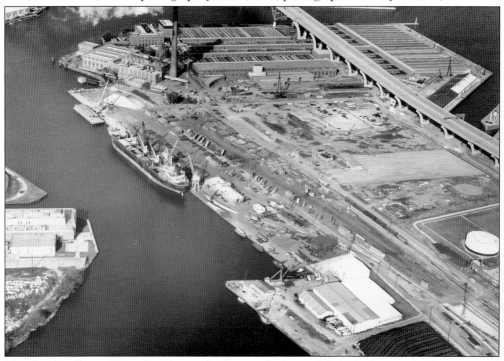

The *Asia Swallow*, of Intership, Inc., is loading at the heavy-lift dock along with a barge owned by Dravo Mechling Company. (Date of photograph: November 8, 1982; photographer: Robert T. McCoy.)

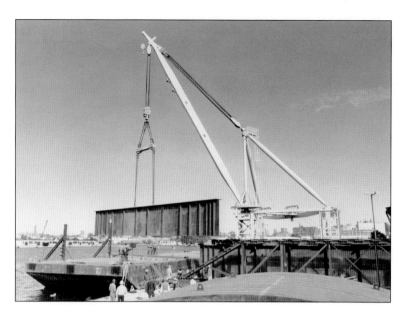

Port of Milwaukee Crane No. 15 is loading Lakeside Steel and Iron Company steel on a barge that will be towed down the lake and through the Illinois Waterway to Lock and Dam No. 21 on the Mississippi River. (Date of photograph: September 13, 1983; photographer: Robert T. McCoy.)

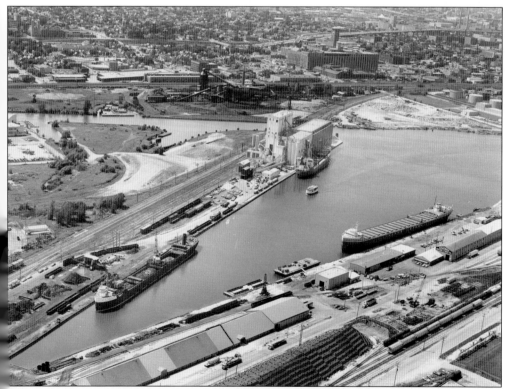

Inland Steel's *L. E. Block* is tied up next to Advance Boiler. The *William H. Donner* is at her normal location as the transfer vessel at Miller Compressing, and *Hans Leonard* is at the grain elevator. (Date of photograph: July 19, 1984; photographer: Robert T. McCoy.)

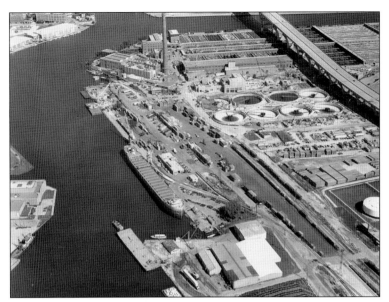

The Milwaukee Metropolitan Sewerage Treatment Plant is at the top of this photograph, with Interstate 794 and the Hoan Bridge at the upper right. The boat at the heavy-lift dock is the *L. E. Block*, and the barge in the foreground is being pushed by the tug *Margaret M.* (Date of photograph: September 16, 1986; photographer: Robert T. McCoy.)

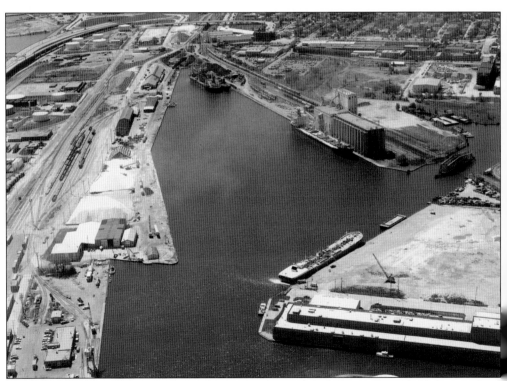

Cleveland Tankers' *Jupiter* is temporarily against the coal dock across Greenfield Avenue from University of Wisconsin-Milwaukee's Great Lakes Water Institute. *Puhos* is at the Continental Grain elevator (today Nidera elevator), and the *Adele R.* is loading or unloading scrap at Miller Compressing and is tied up next to the *William H. Donner*. (Date of photograph: May 15, 1987; photographer: Robert T. McCoy.)

Three

THE OUTER HARBOR

Piers played a role in the start of most Lake Michigan ports, and Milwaukee was no exception, but by and large, the old wooden piers were fairly small and eventually succumbed to the fury of the lake. With Jones Island and the stone piers flanking the straight cut entrance channel as a base, land was filled in both to the north and south, and as the two piers were extended more such land was created.

The southern area, known as the "south tract," was adjacent to the island, and initially it became the site of the Milwaukee Metropolitan Sewerage Treatment Plant, but apart from the old municipal incinerator most of the south tract remained open. As additional stone and concrete piers, along with municipal transit sheds, were added in the 1950s and 1960s, the south tract became what it is today—the outer harbor.

Activity in the "north tract" proceeded more slowly. A lakefront airport, Maitland Field, grew up in the 1920s, and a dock was created for the cross-lake shipment of automobiles. In 1956, in order to protect Milwaukee from air attack as the Cold War heated up, the U.S. Army installed Nike anti-aircraft missiles on Maitland Field and a control building on the bluff next to the North Point Lighthouse. They were removed in the late 1960s.

In the 1950s, a terminal for passengers and their autos was created in the north tract to serve cruise ships visiting Milwaukee. The automobile dock is gone, but the passenger terminal, adjoining the present-day Discovery World, is the home of the reproduction lake schooner *Denis Sullivan*.

Eventually the city abandoned the idea of creating an industrial district like the south tract, choosing instead to use the bulk of the north tract for recreational purposes. In 1970, Summerfest moved into the old Maitland field site and took over the Nike Administration Building as its headquarters. The latest addition, Lakeshore State Park, was created in the early 21st century, with landfill taken from the Milwaukee Metropolitan Sewerage District's deep tunnel for storing storm water.

Around the turn of the 19th to the 20th century, the City of Milwaukee began a program of enclosing its harbor with a breakwater. The early port had two active lighthouses, one on the north breakwater and one on the pierhead light. A light on the bluff at the end of Wisconsin Avenue in 1838 was replaced in 1855 by the North Point Lighthouse in Lake Park. The three lights were supplemented by a lightship, *Light Vessel 95*, anchored offshore from 1912 to 1938. The North Point Lighthouse, decommissioned in 1994, was added to the National Register of Historic Places in 1984.

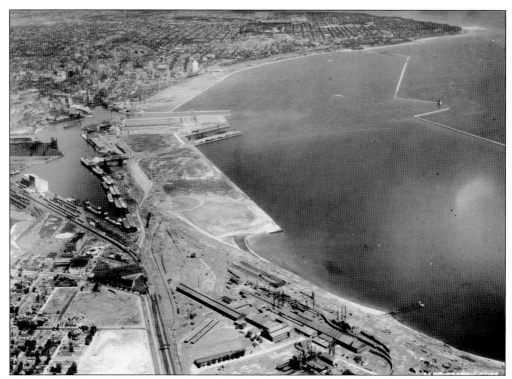

Looking northwest, this view covers the entire Milwaukee Bay from the Illinois Steel Company on the south to all of downtown and beyond as far as Whitefish Bay. A picture taken from the same place today would be quite different, with less water and more land and the Hoan Bridge. (Date of photograph: August 1935; photographer: Aero-Graphic Corporation.)

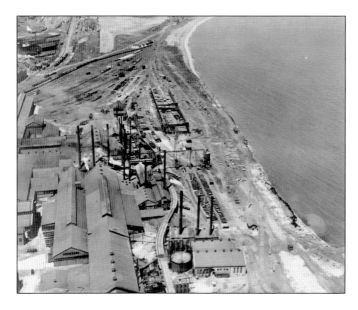

This image is of the Illinois Steel Company plant, looking north from the furnaces. Note the totally undeveloped shoreline of the south tract. (Date of photograph: c. 1927; photographer: unidentified.)

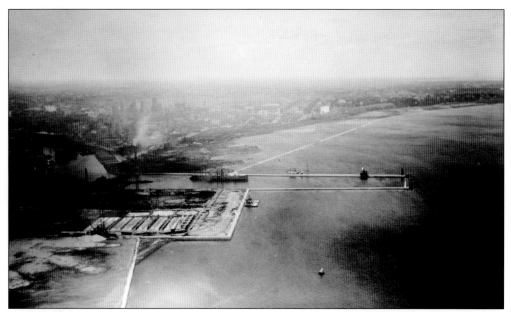

Here is the south tract along the lake around 1923–1924. The only developed area is that adjoining the piers where the sewerage disposal plant is being constructed. Notice the car ferry departing past the lighthouse keeper's residence and the fog bell house to the right of it on the pier. (Date of photograph: c. 1923; photographer: Albert E. Toepfer.)

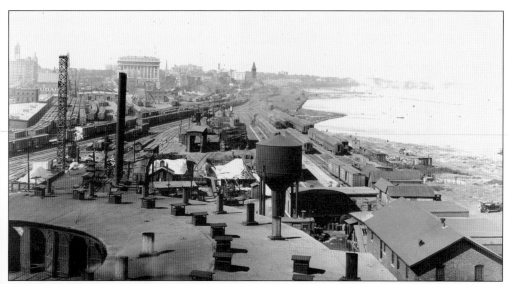

Here is the north tract, which is north of the harbor entrance, looking north from the top of the Chicago Northwestern Railroad roundhouse. Note that the land has tracks and buildings, but there is no development along the lakeshore. The tall, Greek Revival building to the top left is the Northwestern Mutual Life Insurance Building, and to the right is the clock tower of the Chicago Northwestern Railway station. (Date of photograph: 1923; photographer: F. A. Kaiser.)

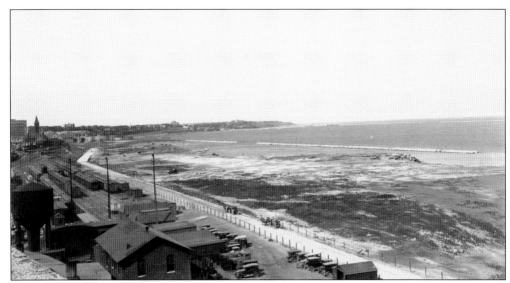

This shows the north tract, with much of the sprawl having already been cleaned up along the lakeside. Note that wagons and teams of horses were still in use. (Date of photograph: 1923; photographer: unidentified.)

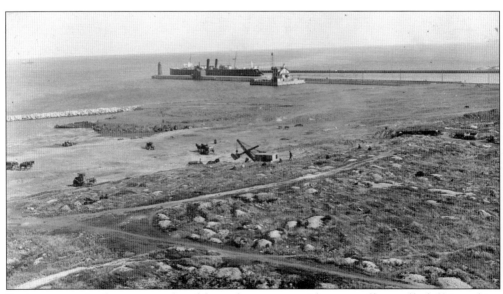

Equipment ranging from a steam shovel (center) to a wagon with a team of horses (far left) is working on improvement of the north tract. The land was being graded for harbor development, most of which never developed as planned. (Date of photograph: 1923; photographer: F. A. Kaiser.)

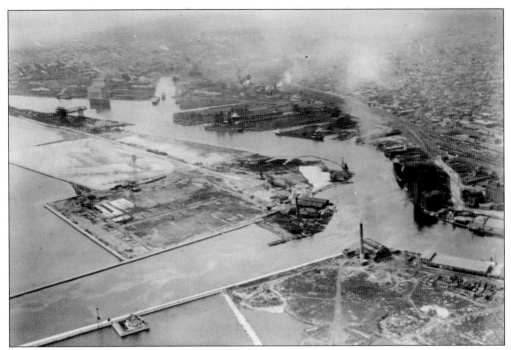

This picture that looks south gives a good idea of the harbor entrance and the south and north harbor tracts. The harbor mouth was being dredged and widened. The old incinerator is visible below at the fork of the Kinnickinnic, and above and to its left is the sewerage treatment plant. The lighthouse keeper's residence is near the breakwater to the lower left. Both harbor tracts are otherwise pretty much devoid of any structures save for the shanties of the fisher folk of Jones Island. (Date of photograph: c. 1921; photographer: unidentified.)

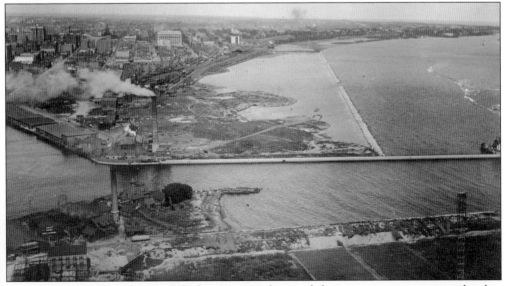

This picture is looking north, with the sewerage plant and the incinerator opposite each other where the Kinnickinnic and Milwaukee Rivers diverge. Except for the train yard, the north tract is pretty much undeveloped. The point of land by the sewerage treatment plant was later removed. (Date of photograph: 1924; photographer: F. A. Kaiser.)

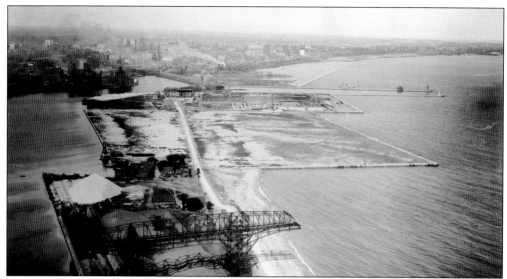

Looking north, there is a road to the sewerage treatment plant. The end of the bridge crane on the inner harbor is visible, but only one block of landfill is evident, located just to the south of the sewerage plant. (Date of photograph: early 1924; photographer: unidentified.)

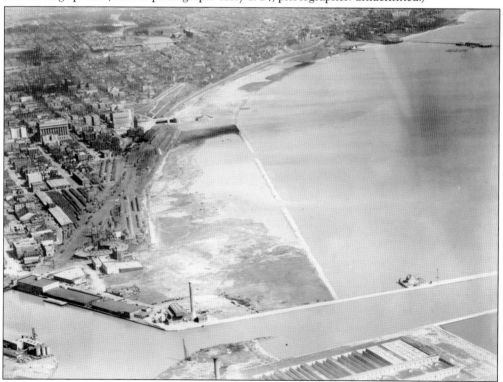

In this view of the north tract, the wall forming the start of the landfill is clear as it runs from the center left to the lower center right. The land is only partially filled. Today all the area east of the lighthouse keeper's house (lower right) has been filled and makes up the Summerfest Grounds and the new Lakeshore State Park. (Date of photograph: June 1927; photographer: Charles M. McCreedy, Inc.)

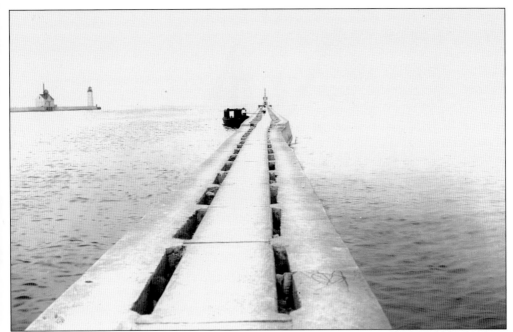

The south bank of the entrance channel was extended lakeward at the south pierhead, ending with a small light opposite of the larger lighthouse on the northern bank. This is the south pierhead nearly completed. (Date of Photograph: 1910; photographer: United States Corps of Engineers photograph.)

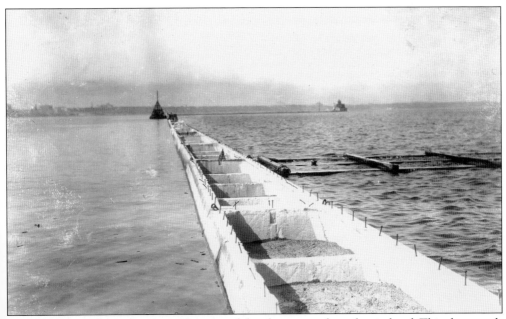

In 1927–1928, work was done extending a south breakwater out from the pierhead. This photograph shows the south breakwater prior to the placing of capstones. (Date of photograph: unidentified; photographer: United States Corps of Engineers.)

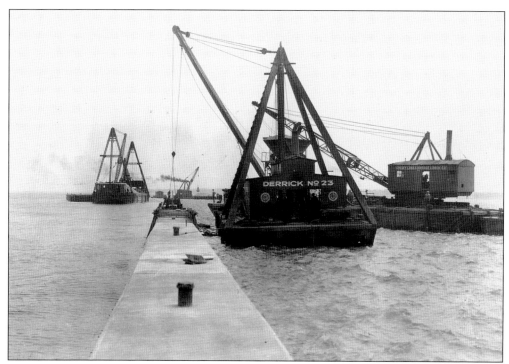

Great Lakes Dredge and Dock derricks and cranes are capping the south breakwater. (Date of photograph: unidentified; photographer: United States Corps of Engineers.)

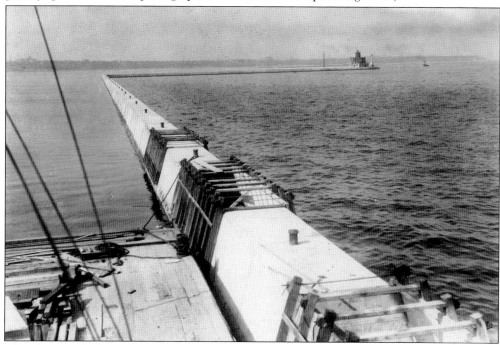

This photograph shows the forms for the concrete breakwater caps. The breakwater is filled with stone and then capped with concrete. (Date of photograph: unidentified; photographer: United States Corps of Engineers.)

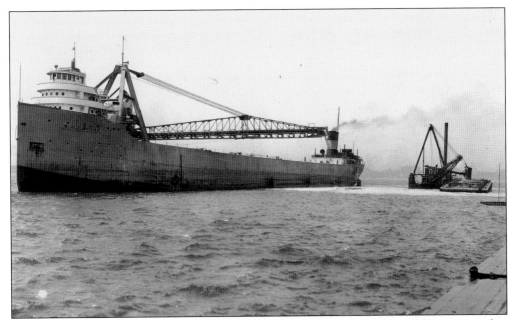

Self-unloading freighters, like the *B. H. Taylor* in this photograph, were carefully positioned to accurately place stone for the breakwater. On this, the cribbing was then constructed. (Date of photograph: 1924; photographer: Edward E. Gillen Company.)

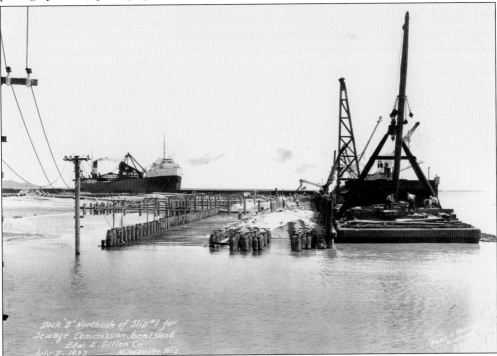

The slips for the piers supporting the outer harbor terminal structures were built in a manner similar to the breakwaters. Here the *W. E. Fitzgerald* and barges are placing sand and pouring concrete to form the north side of slip type "B" dock. (Date of photograph: July 2, 1932; photographer: Brown and Rehbaum.)

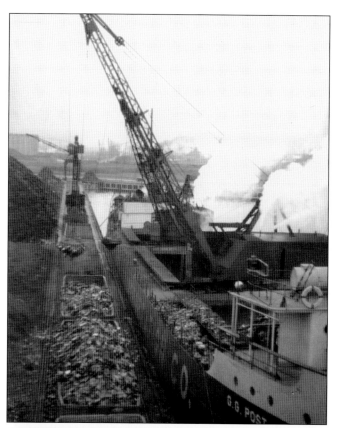

The first outer harbor pier was in operation by 1937, as seen in this picture of the crane ship G. G. *Post*, which is unloading scrap metal by use of a magnet at South Pier No. 1. (Date of photograph: May 19–21, 1937; photographer: unidentified.)

Chesapeake and Ohio car ferry *City of Saginaw* 31 passes the breakwater lights as it arrives in Milwaukee from Ludington, Michigan. (Date of photograph: unidentified; photographer: Platz Studio.)

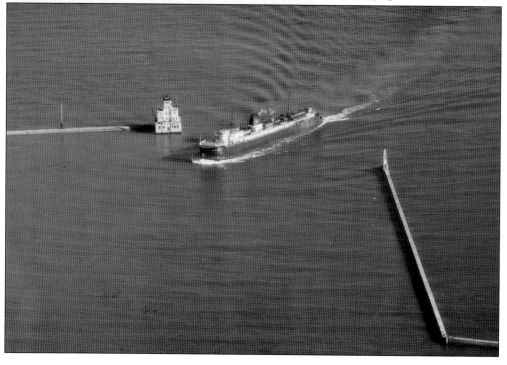

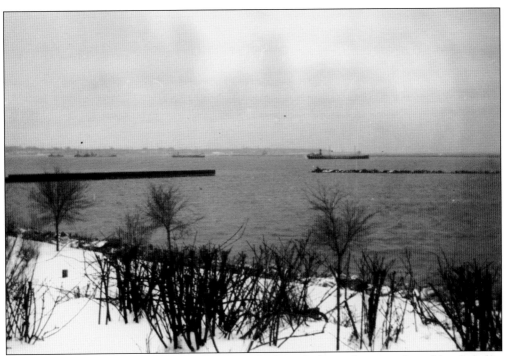

The breakwaters allowed Milwaukee to become a harbor of refuge, where vessels could seek shelter in storms. This photograph shows five ships protected by the breakwater from rough seas. (Date of photograph: April 1950; photographer: W. J. Lawrie.)

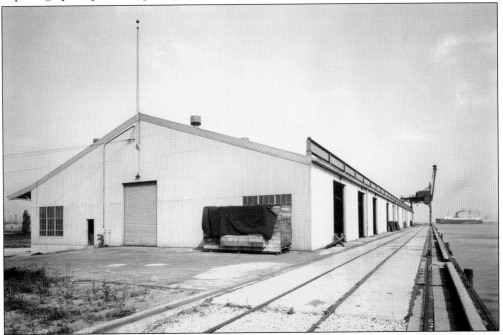

Looking east along the dock, this image is of the Municipal Transit Shed No. 1. No ships are tied up at the dock, but a Chesapeake and Ohio car ferry headed for the inner harbor is visible beyond it. (Date of photograph: November 1953; photographer: P&V Atlas.)

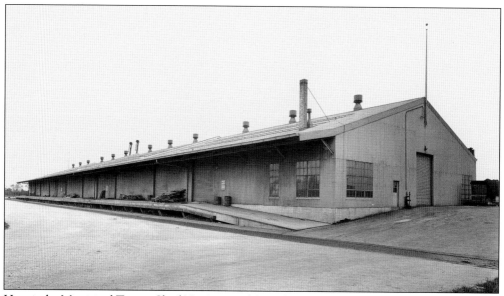

Here is the Municipal Transit Shed No. 1 viewed from the north. (Date of photograph: November 1953; photographer: P&V Atlas.)

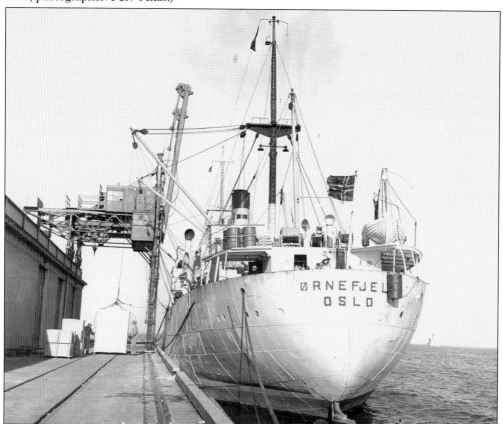

The SS *Ornefjell* is loading export cargo at Municipal Transit Shed No. 1. (Date of photograph: 1952; photographer: John S. Blank.)

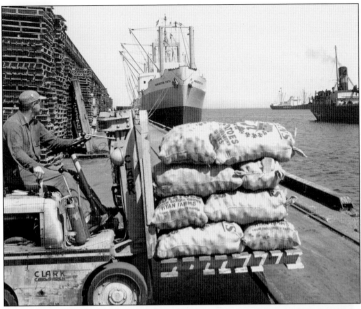

Seed potatoes from Ryan Farms of Grand Forks, North Dakota, and consigned to Cuba are being moved by forklift at the Municipal Transit Shed No. 1 dock. The British freighter *Manchester Faith* is in the background. (Date of photograph: September 9, 1959; photographer: Clair J. Wilson.)

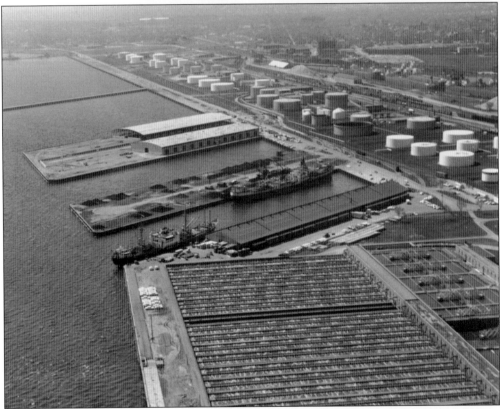

Looking south, the sewerage plant is in the foreground, followed by the Municipal Transit Shed No. 1 to the south. Then there is a ship on the north side of Pier 1, and beyond General Cargo Terminals No. 2 and No. 3 are nearing completion. (Date of photograph: June 1961; photographer: unidentified.)

This image was taken looking northeast from the southwest corner of South Pier No. 2. To the extreme left, blocked by Transit Shed No. 3, one can make out Transit Shed No. 2. Transit Shed No. 3 is being built and is still minus walls. Parked to the right is a Wisconsin-built American Motors (Nash) Rambler automobile. (Date of photograph: June 12, 1961; photographer: Brown and Rehbaum.)

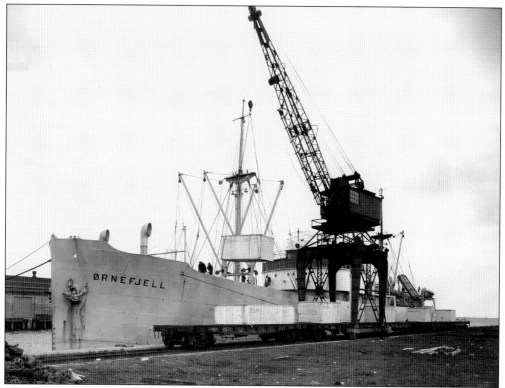

The Board of Harbor Commissioners' gantry crate is loading four wheel–drive trucks for export on to the SS *Orenfjell* in May 1946. She was the first overseas ship to dock at Milwaukee since 1941, marking the resumption of lakes to ocean service after the Second World War. (Date of photograph: May 7, 1946; photographer: Board of Harbor Commissioners.)

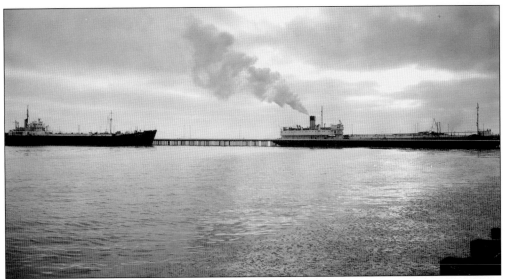

South Pier No. 5 is also known as the liquid cargos dock because of the nature of the traffic it serves. The oil storage tanks, visible elsewhere in the inner harbor, are connected to this pier, which is due for renovation in the near future. In this 1955 photograph, the *Meteor* (whaleback tanker) and the *Polaris* (left) are discharging cargo. (Date of photograph: December 27, 1955; photographer: Brown and Rehbaum.)

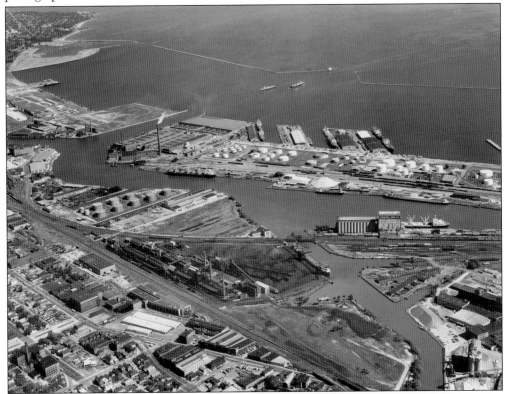

The storage tanks for liquid cargos are clearly visible on both sides of the inner harbor in this photograph. (Date of photograph: September 11, 1970; photographer: Clair J. Wilson.)

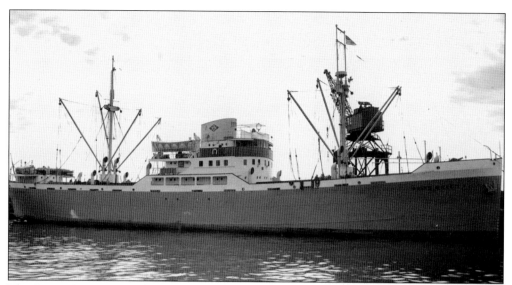

The Oranje Line's *Prins Willem* V is docked at South Pier No. 1. This vessel later came to grief in a collision with the towline of a tug/barge off Milwaukee's harbor in October 1954, and today the ship's remains are a popular dive target. (Date of photograph: 1953; photographer: unidentified.)

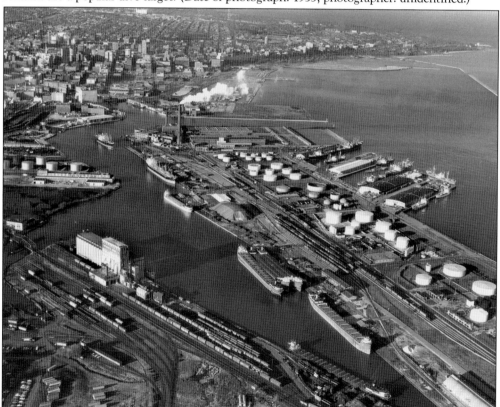

This aerial photograph, looking east, offers a nice view of Piers No. 1 and No. 2 with their transit sheds. It must have been a pretty busy time, since at least nine ships appear to be tied up in the outer harbor. (Date of photograph: November 13, 1967; photographer: Clair J. Wilson.)

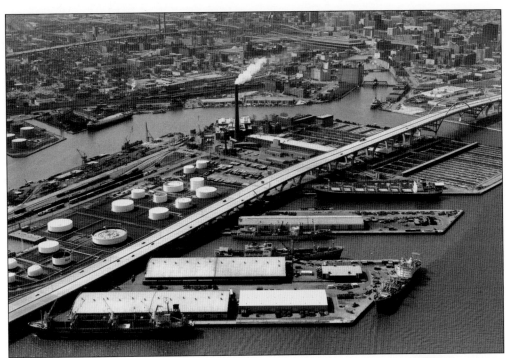

This aerial photograph, with a northwest approach, clearly shows off the facilities of the outer harbor. Here there are five saltwater vessels at dock. One can also see Interstate 794, running above the inner edge of the piers, and the Hoan Bridge, which is crossing the entry channel. (Date of photograph: May 1, 1979; photographer: Clair J. Wilson.)

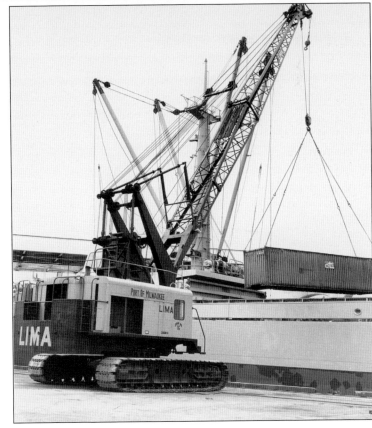

Mobile Crane No. 16 is loading a 40-foot container on board the *Juno* at Terminal No. 1. Container traffic is nothing new to the Port of Milwaukee. (Date of photograph: July 6, 1972; photographer: Clair J. Wilson.)

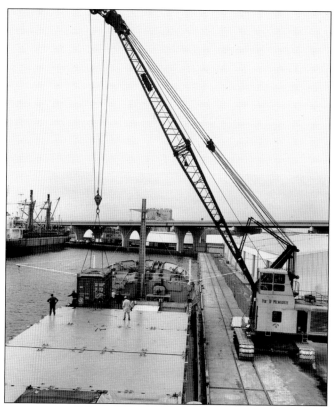

Here Mobile Crane No. 16 is loading containers on Manchester Lines' *Manchester Mercurio*. Interstate 794 is clearly visible in the background, although it did not open to vehicle traffic until 1977. (Date of photograph: August 19, 1975; photographer: Clair J. Wilson.)

This is the dedication ceremony for the new mobile Crane No. 17 at South Pier No. 2. (Date of photograph: October 4, 1979; photographer: Harnischfeger.)

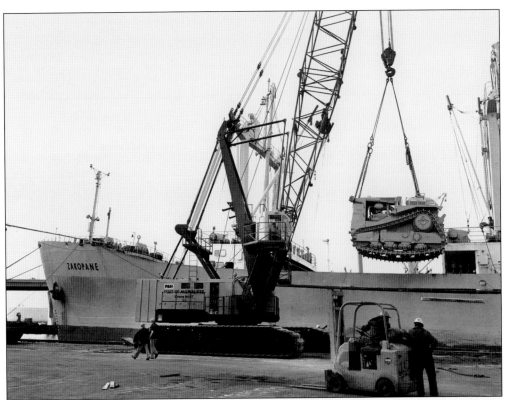

The lifting power of Crane No. 17 is being put to work loading Caterpillar bulldozers on the Polish Ocean Lines' freighter *Zakopane* at General Cargo Terminal No. 3. (Date of photograph: October 10, 1979; photographer: Clair J. Wilson.)

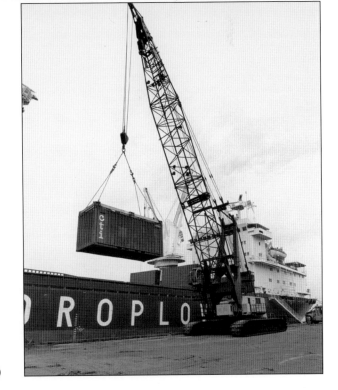

A crane is loading Yugoslavian freighter *Admiral Pursic* with containers at General Cargo Terminal No. 3. (Date of photograph: November 5, 1979; photographer: Smith-Middleton.)

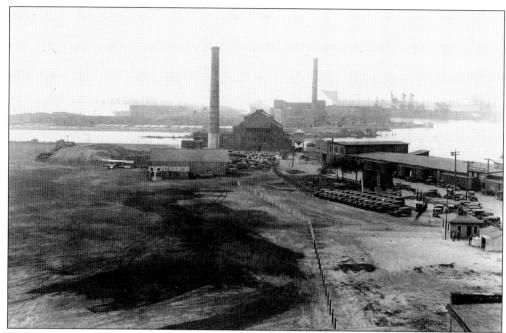

The north tract also underwent development but in a different direction. Here it is fully graded and being developed into one of Milwaukee's earliest airports, Maitland Field. (Date of photograph: June 4, 1929; photographer: Kaiser.)

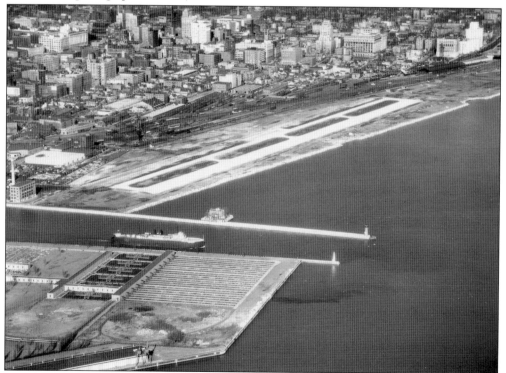

Maitland Field's runways are clearly evident north of the north pier and the light keeper's residence, with the old incinerator to the left. (Date of photograph: 1949; photographer: Gruenberger Air Pix.)

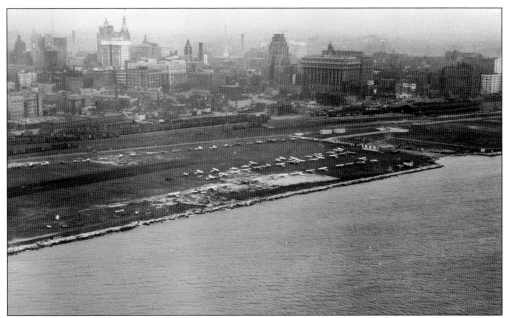

There were 71 planes of Wisconsin Elks at Maitland Field in November 1946. Note that city hall, located in top left corner, was still the tallest building in Milwaukee. This remained until the U.S. Bank Building, originally the First Wisconsin Center, was built in 1973. (Date of photograph: November 1946; photographer: Milwaukee Seadrome.)

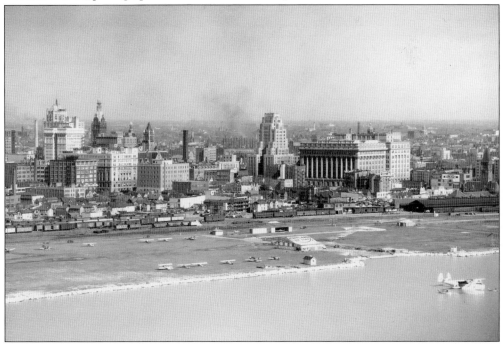

This view of Maitland Field and the Municipal Air Marine Terminal in 1948 shows it complete not only with many land airplanes but also a large flying boat with a ramp. Downtown has grown, but individual homes are still visible. (Date of photograph: May 1948; photographer: Gruenberger Air Pix.)

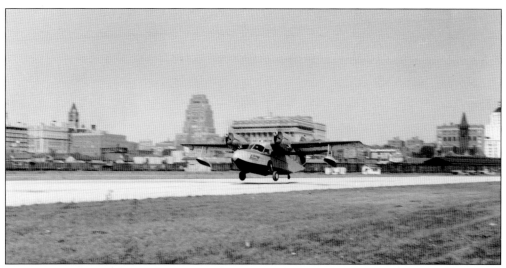

Here is a smaller amphibian aircraft landing at Maitland Field on land and not on the water. (Date of photograph: unidentified; photographer: unidentified.)

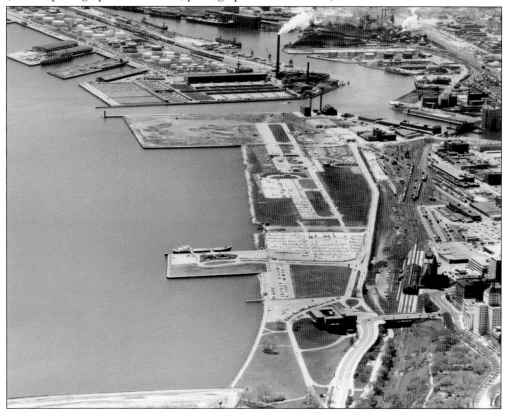

After air traffic moved elsewhere, efforts were made to develop the north tract for shipping. Here the *Highway 16* (now museum ship LST-393 in Muskegon, Michigan) is unloading a cargo of automobiles. A number of autos are visible to the south in a parking area and on the old Maitland Field runways, as is the War Memorial Center. (Date of photograph: May 13, 1965; photographer: Clair J. Wilson.)

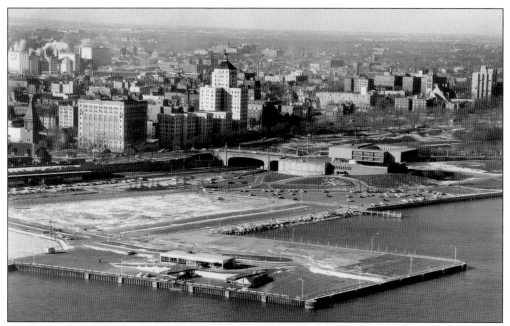

To the north, Milwaukee developed a Municipal Passenger Terminal and Auto Pier. In this photograph, the structure has recently been completed, and landscaping is underway. Note the Chicago Northwestern Depot's clock tower with the Schlitz Brewery on the left and the Cudahy Towers standing proudly in the center. (Date of photograph: November 17, 1959; photographer: Clair J. Wilson.)

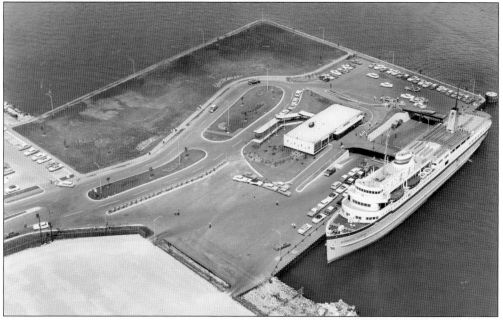

The main user of the Milwaukee Municipal Passenger Terminal was the *Milwaukee Clipper*, shown here tied up and loading passengers and vehicles. Today the passenger terminal is the site of the popular Discovery World with the Pieces of Eight restaurant, now called the Harbor House, across the street. (Date of photograph: September 1960; photographer: Robert T. McCoy.)

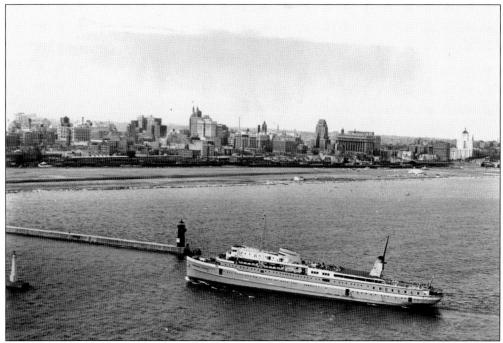

Prior to the construction of the Milwaukee Municipal Passenger Terminal, the *Milwaukee Clipper* had to use dock facilities in the inner harbor. Here she is headed in between the piers, just past the pierhead lighthouse. (Date of photograph: summer 1953; photographer: Fred R. Stanger.)

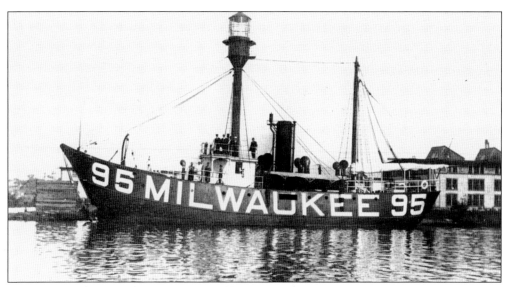

Before the breakwater lights were ready and later to supplement them, the Port of Milwaukee used the services of a lightship. The regular vessel was *Light Vessel 95*, seen here at one of her rare visits to shore. (Date of photograph: unidentified; photographer: Fr. Edward J. Dowling, S. J.)

Four
MENOMONEE RIVER AND ADJACENT CANALS

From the late 19th century through the mid-20th century, the Menomonee River valley was a center of heavy industry. It was part of the port—an industrial district of hundreds of acres, served by extensive rail connections and several man-made canals. Raw materials and finished products could be shipped in and out by water, which was the least expensive mode of transportation.

Large ships brought in cargos of coal, lumber, and cement and took out grain and finished manufactured products, such as sashes and doors, leather goods, and even beer. It was the site of a Pfister and Vogel tannery, part of the Pabst Brewing Company, a stockyard with meatpacking plants, brickyards, distilleries, and the repair shops of the Chicago, Milwaukee, and St. Paul Railroad (the Milwaukee Road).

There were 6 miles of dock frontage, and numerous grain elevators and coal yards, lining the banks of the Menomonee River along with the Burnham Canal, the North Menomonee Canal, the South Menomonee Canal, and the now mostly filled-in Kneeland Canal, thus making the area one of the leading industrial centers of the Midwest.

There are still rail yards and industry there today, but as in most of the old industrial cities, much has changed. The old Wisconsin Electric Company, which supplies most of the electricity to the area, is still located on one of the canals and still receives its coal supply by water, but it is now delivered by barges loaded in the inner harbor from cargos delivered there by lake freighter.

The intersection of the Menomonee and Milwaukee Rivers was once extremely busy, causing fireboats to be docked nearby, just in case, for easy access to either river. In 1917, it was the scene of one of Milwaukee's few marine disasters, when the whaleback passenger vessel *Christopher Columbus* tipped over a water tank, causing 16 deaths and numerous injuries.

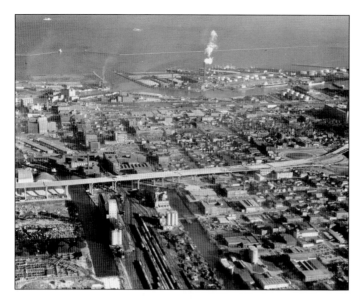

Here is an aerial photograph of the harbor district being built, looking east toward Lake Michigan. The road in the center is Interstate 94. The two channels on the lower left are the Menomonee River and to the right is the Burnham Canal. (Date of photograph: unidentified; photographer: unidentified.)

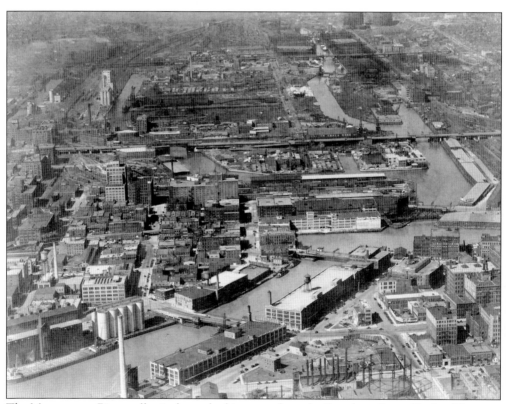

The Menomonee River valley is shown looking west from the Broadway Street Bridge. The next bridge is Water Street Railroad Bridge, then Second Street Bridge, with Sixth Street looking like a major thoroughfare. (Date of photograph: unidentified; photographer: Holmberg Air Mapping Company, Inc.)

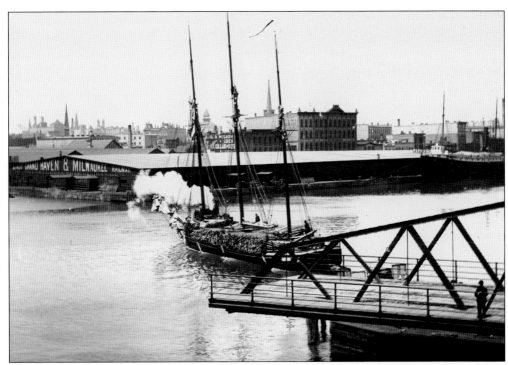

A schooner is shown with what appears to be a cargo of pulpwood near the North Water Street Bridge at the fork of the Milwaukee and Menomonee Rivers. Note the warehouse of the Grand Haven and Milwaukee Railroad and the passenger freighter tied up on far right. (Date of photograph: c. 1885; photographer: H. H. Bennett Studio.)

A schooner, a fire tug, and a cement barge are at the junction of the Milwaukee and Menomonee Rivers. Fire tugs were docked in this area to have ready access to the whole river system and port. (Date of photograph: 1952; photographer: unidentified.)

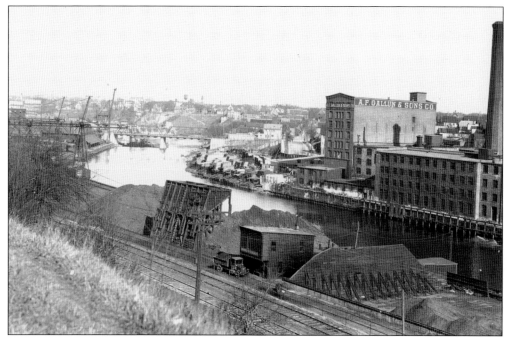

Here is one of the coal yards along the Menomonee River. The Menomonee Valley was, and remains today, a major industrial district. It formerly relied on waterborne commerce to provide raw materials and to ship finished products. (Date of photograph: unidentified; photographer: unidentified.)

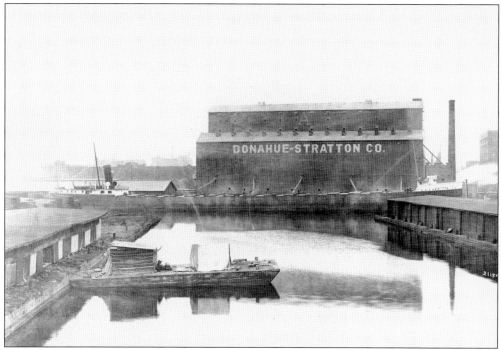

A freighter is loading grain at the Donahue and Stratton elevator, while a barge is tied up on one of the side channels, along which appear to be storage sheds for plywood. (Date of photograph: unidentified; photographer: unidentified.)

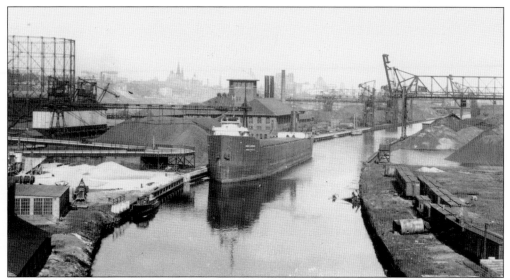

A lake freighter is shown passing the coal yard on Menomonee River. The bridge crane in the background is used for loading and unloading, and there is a lumberyard in the right foreground. (Date of photograph: unidentified; photographer: Edwin Wilson.)

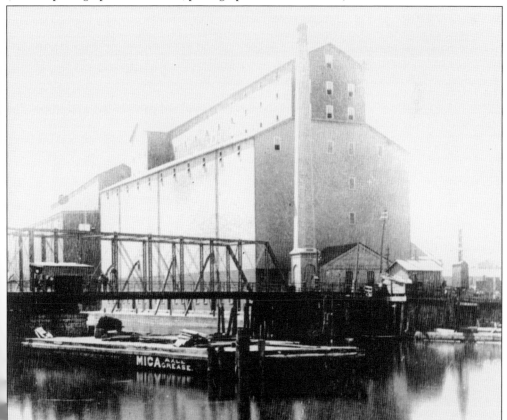

Shown is a grain elevator along the Menomonee River with a barge passing under a bridge. (Date of photograph: unidentified; photographer: unidentified.)

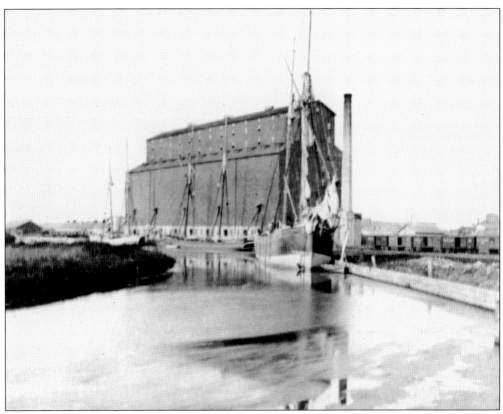

Here is Grain Elevator A of the Chicago, Milwaukee, and St. Paul Railroad, located along the Menomonee River, with schooners tied up in front and rail cars behind to facilitate the transshipment of grain. (Date of photograph: unidentified; photographer: Victor Craun.)

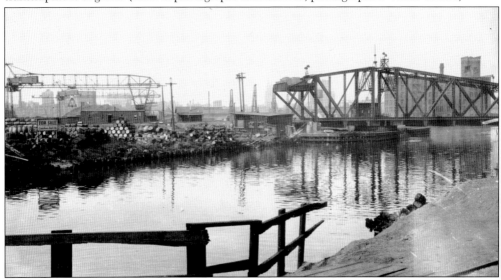

Here is the swing bridge at the confluence of the Menomonee and Milwaukee Rivers, near Burnham Canal. This bridge still exists and is used by Amtrak and the Canadian Pacific Railway. (Date of photograph: 1931; photographer: unidentified.)

A self-unloading freighter at a coal yard on the Menomonee River is viewed from Sixth Street, out of sight on right. The elevator in the lower right corner is either grain or more likely cement. (Date of photograph: 1957; photographer: unidentified.)

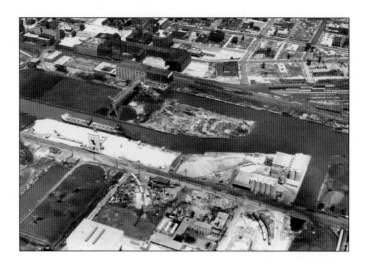

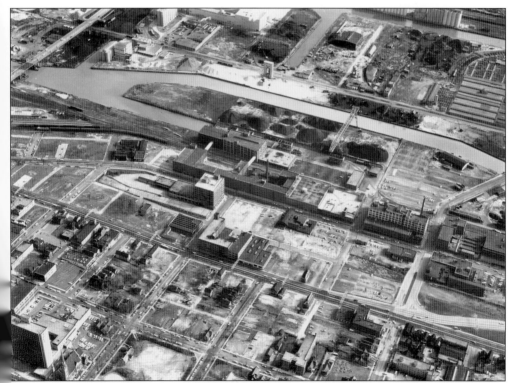

This is a photograph of the Menomonee River, looking south. To the upper left are Sixth Street and the remains of the old Kneeland Canal. To the bottom left are the former YMCA, now Marquette University's Straz Tower, and Calvary Presbyterian Church at Tenth and Wisconsin Streets. (Date of photograph: 1965; photographer: unidentified.)

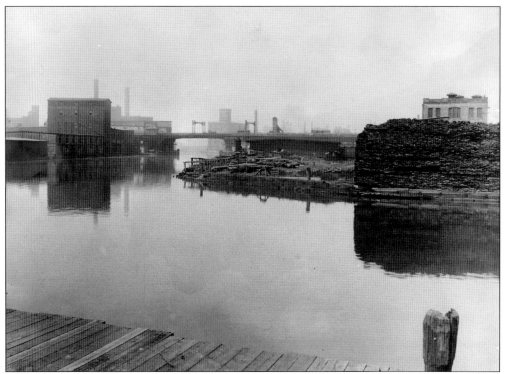

On a somewhat foggy day, this is of the Menomonee Canal, looking west toward the Sixth Street Viaduct. Note the large quantity of lumber stacked to the right and Vogel Leather Company across Sixth Street. (Date of photograph: unidentified; photographer: unidentified.)

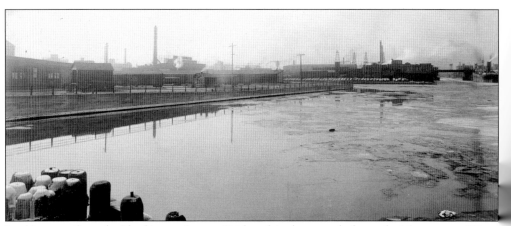

Looking west from the Plankinton Avenue Bridge, this photograph shows the Menomonee River. To the left and in the middle foreground is the Milwaukee Road railroad open dock. (Date of photograph: unidentified; photographer: Carney Photographs.)

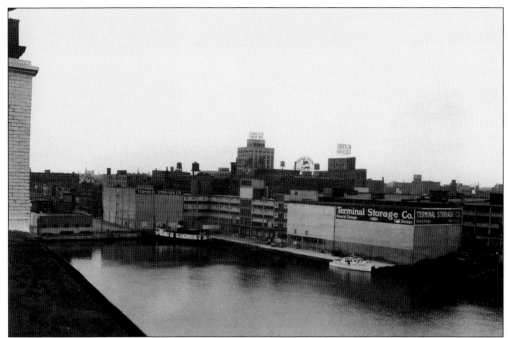

Terminal Storage Company was located at the junction of the Menomonee and Milwaukee Rivers. The tall building in the center is now Teweles Seed Tower Apartments (222 South Third Street), and to the right is the S. G. Courteen Seed Warehouse (222 West Pittsburgh Street). (Date of photograph: 1949; photographer: unidentified.)

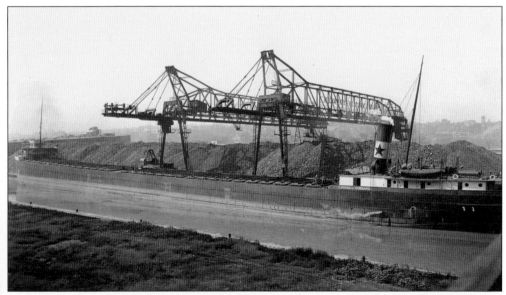

The freighter C. *Russell Hubbard* is being unloaded by bridge crane at the Northwestern Hanna Coal Company dock, located at Seventeenth Street and the Menomonee River. (Date of photograph: unidentified; photographer: unidentified.)

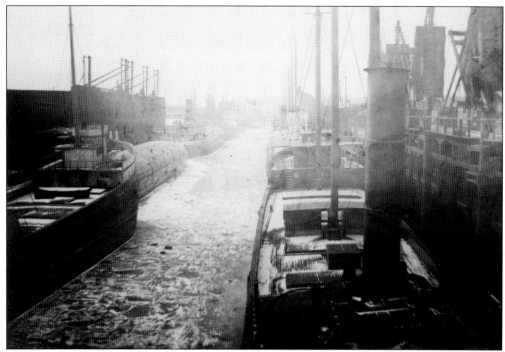
Here is the winter lay-up fleet in the Menomonee River, west of the Sixteenth Street Viaduct. Note the whaleback barges and steamer on the left side as well as the hatch cover that is open on the steamer on the right. (Date of photograph: winter 1903–1904; photographer: unidentified.)

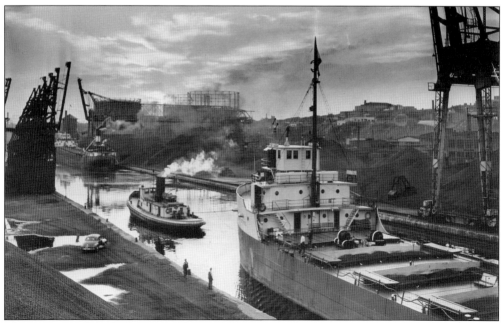
The tug *Conrad Starke* is towing the freighter *William T. Stifel* in the Menomonee River. The freighter *Amazon* is in the background at the Western Fuel Company dock. (Date of photograph: 8:00 p.m., August 15, 1945; photographer: unidentified.)

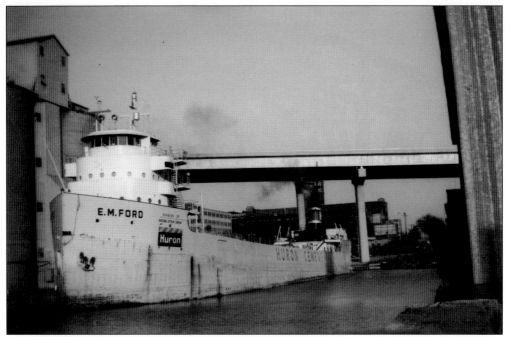

Cement carrier *E. M. Ford* is shown in the Menomonee River, just west of the Interstate 94 Bridge. (Date of photograph: unidentified; photographer: unidentified.)

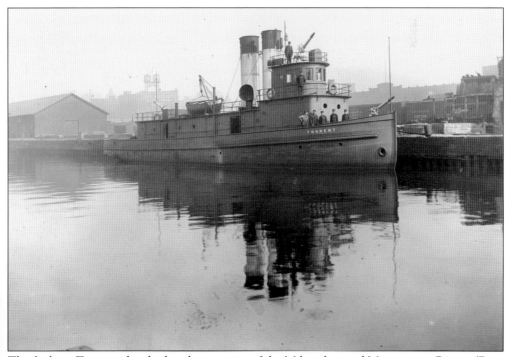

The fireboat *Torrent* is berthed at the junction of the Milwaukee and Menomonee Rivers. (Date of photograph: October 31, 1922; photographer: Henry H. Hunter.)

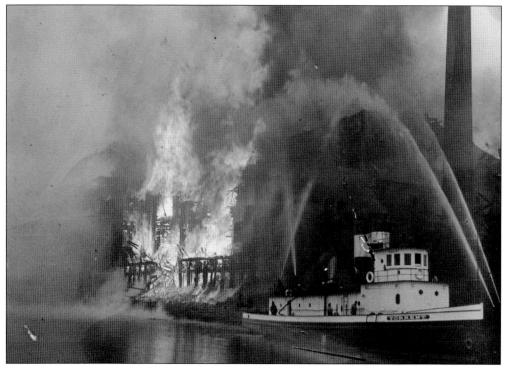

The Milwaukee Fire Department tug *Torrent* is fighting a grain elevator fire, which appears to have just about consumed the structure. (Date of photograph: unidentified; photographer: unidentified.)

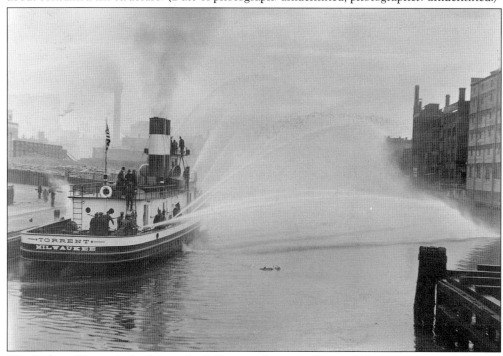

The fireboat *Torrent* is displaying firefighting techniques. (Date of photograph: May 16, 1922; photographer: unidentified.)

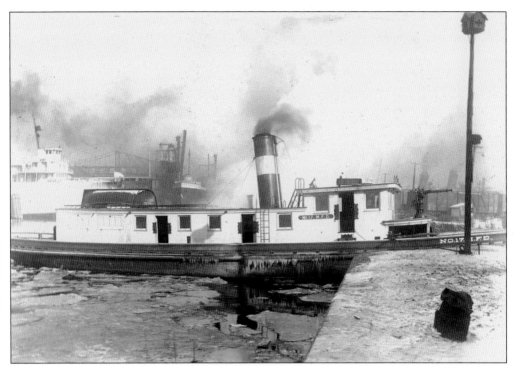

The fire tug *MFD 17* stands ready on a chilly winter day, with a Pere Marquette railroad car ferry coated in ice in the background. (Date of photograph: January 28, 1925; photographer: unidentified.)

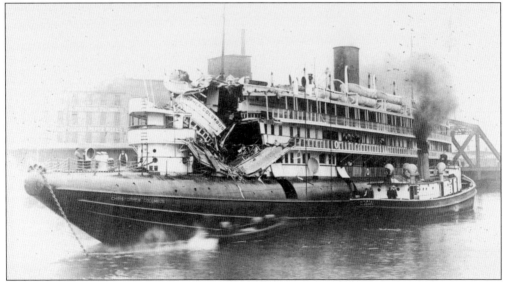

The Goodrich passenger steamer *Christopher Columbus* ran daily excursions between Chicago and Milwaukee. She had a perfect safety record from 1893 until Saturday, June 30, 1917, when attempting to turn at the junction of the Milwaukee and Menomonee Rivers to head out to the lake, a strong current caused her bow to strike and topple a water tank, which crashed on top of her pilothouse. A total of 16 people lost their lives and 20 more sustained serious injury in the incident. It was the only mishap in her long career on the lakes. (Date of photograph: June 30, 1917; photographer: unidentified.)

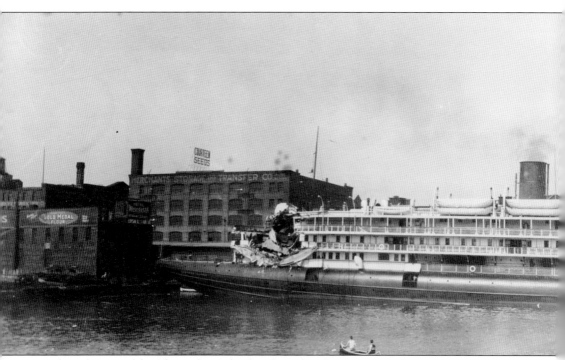

This side view of the *Christopher Columbus* shows her damage from a slightly different angle. Many of the injured passengers were excursionists from the University of Chicago. (Date of photograph: June 30, 1917; photographer: unidentified.)

Five

The Milwaukee River

The Menomonee River Valley served primarily as an industrial district, whereas the Milwaukee River ran to the north, providing passage for vessels through the heart of the city. At one time, the river served as the dividing line between the settlements of Byron Kilbourn (Kilbourntown) and Solomon Juneau (Juneautown). In the early years, the two communities were very competitive and, from time to time, residents nearly came to blows. The purposeful laying out of streets on the east and west sides of the river—so as not to match up—resulted in today's diagonal Wisconsin Avenue Bridge.

The northern navigable reaches of the river were given over to industry, and many large freighters had to be assisted by tugs as they picked their way through the city and up the river to the coal and lumberyards and manufacturing plants that were located there. In those days, the city's bridges had to be of the bascule type so as to allow the sailing ships and ships with tall superstructures to get by. Also, long before the creation of the Municipal Passenger Terminal on the lakefront, major shipping companies, like Goodrich Transit Company and Pere Marquette, delivered and picked up their passengers in the heart of the city.

As time passed, with travel habits changing and street traffic becoming far more important than water traffic, the large ships disappeared from the river. The types of bridges also changed, often to lift bridges that are more reliable and less prone to being stuck in the open position. Freight traffic on the river dwindled to a few barges, pushed by small tugs, and local excursion and sightseeing vessels like the *Iroquois*. The two *Edelweiss* boats took the place of cross-lake passenger steamers.

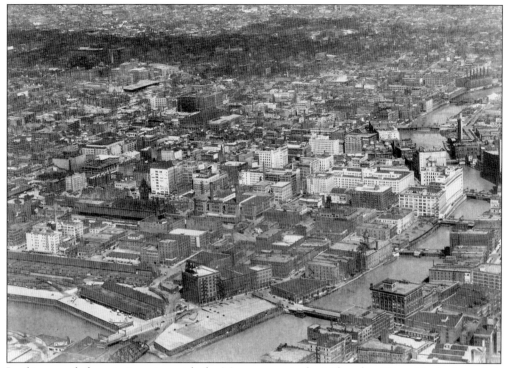

Looking north from its junction with the Menomonee is the Milwaukee River. To the lower left is the Second Street Bridge. (Date of photograph: unidentified; photographer: Holmberg Air Mapping Company, Inc.)

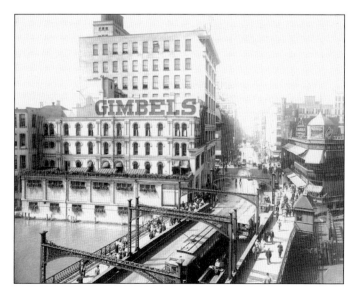

This shot looks west across the old Wisconsin Avenue Bridge. Note the streetcars and catenaries on the bridge. The Gimbels Building is still there but is today occupied by Borders bookstore. (Date of photograph: c. 1900; photographer: unidentified.)

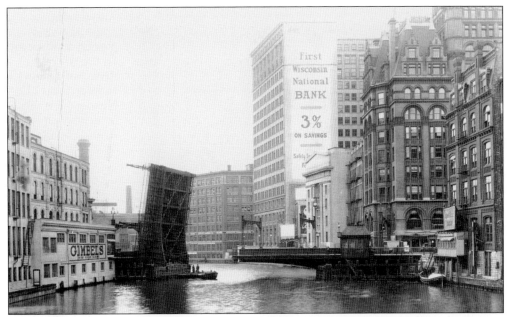

This image looks north to the Wisconsin Avenue Bridge. This is a bascule bridge with the west leaf opened. Gimbels is on the west, and the Pabst Building is on the east, with the First Wisconsin National Bank behind it. Note the whaleboat at the foot of the stairs, just to the right on the east bank. (Date of photograph: after 1914; photographer: unidentified.)

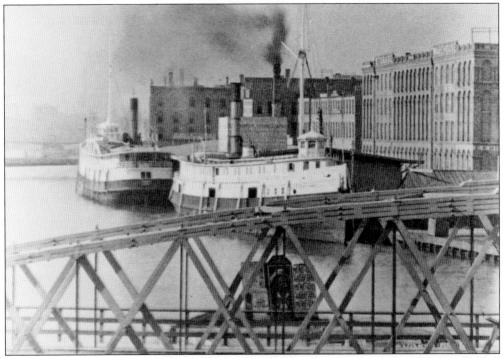

The vessel names are not legible in this old Milwaukee River scene. Note that the bridge in the foreground is a swing bridge, allowing vessels of any height to pass. (Date of photograph: unidentified; photographer: Munger Studio.)

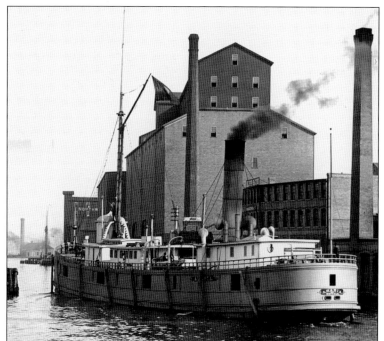

The wooden propeller *Arabia* is moving downstream on the Milwaukee River past a grain elevator. (Date of photograph: *c.* 1880; photographer: H. H. Bennett Studio.)

Above the Juneau Avenue Bridge, the schooner *Edward E. Skeele* is tied up in the Milwaukee River. Across the river is the Electric Company Commerce Street Plant. (Date of photograph: unidentified; photographer: unidentified.)

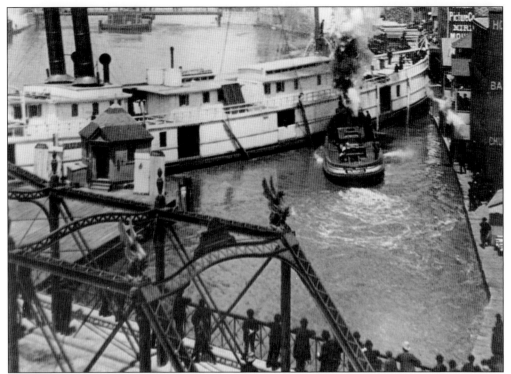

This early Milwaukee River scene shows the tug *Starke Brothers* maneuvering the package freighter *Russia* out of a tight spot. The swing bridge in the foreground has closed, and a crowd has gathered to see her put back on course. (Date of photograph: c. 1886; photographer: Munger Photo Studios.)

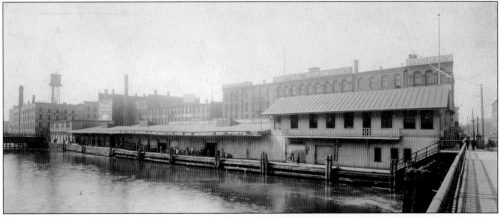

Here is the Goodrich Transit Company dock on the Milwaukee River. (Date of photograph: prior to 1933; photographer: unidentified.)

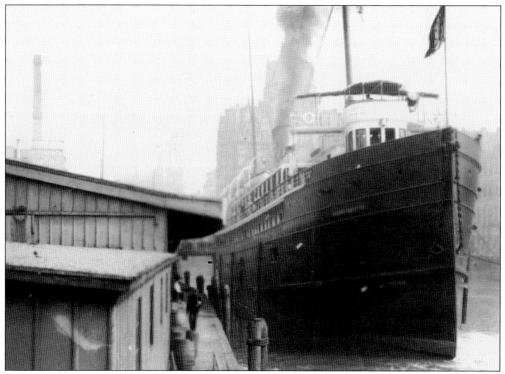

The Goodrich passenger and package freight steamer *Arizona* is loading at the company dock on the Milwaukee River. (Date of photograph: unidentified; photographer: unidentified.)

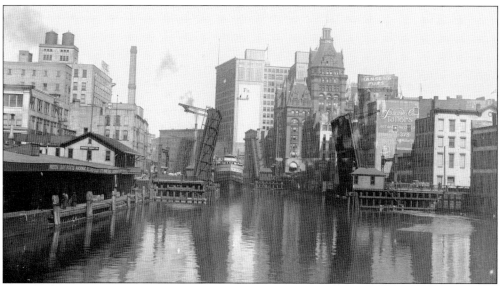

Goodrich Transit Company dock is to left. A vessel is passing through the Wisconsin Avenue bascule bridge and continuing toward the Michigan Street Bridge. The Pabst Building is to the right of the uplifted bridge. (Date of photograph: unidentified; photographer: unidentified.)

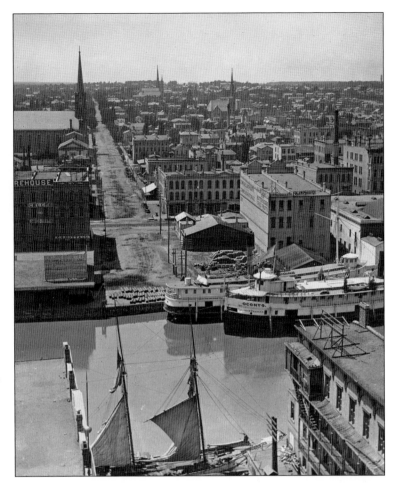

This is an early view of the Milwaukee River looking west up Sycamore Street (later Michigan Street) from the Mitchell Building that shows two early Goodrich Transit Company steamers. To the left is the dock of the Flint and Pere Marquette Railroad Company. St. Gall's Church is in the upper left, located on Sycamore and South Second Streets. Above the *Oconto*'s bow is the drainpipe yard. Note also the schooner in the foreground. (Date of photograph: between 1872 and 1883; photographer: H. H. Bennett Studio.)

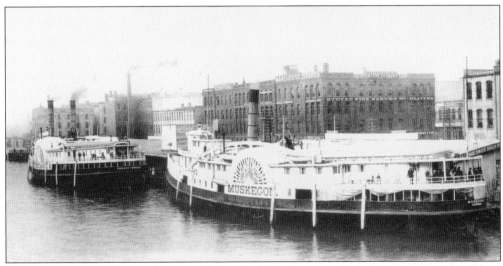

Goodrich Transit Company steamers *Chicago* and *Muskegon* are docked in the Milwaukee River. (Date of photograph: *c.* 1889; photographer: unidentified.)

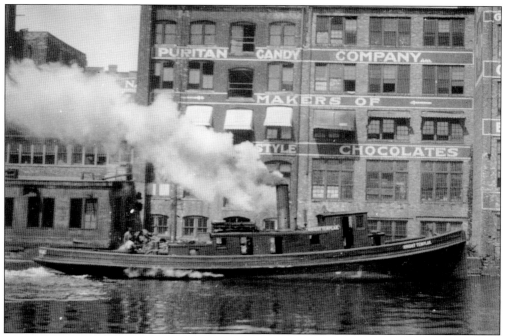

The tug *Knight Templar* is proceeding up the Milwaukee River, past the Puritan Candy Company. (Date of photograph: unidentified; photographer: Edwin Wilson.)

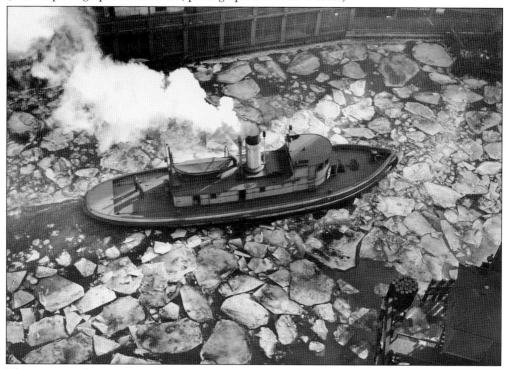

The tug *Conrad Starke* (later *Roger*) is viewed from the top of the Empire Building (at Wisconsin Avenue Bridge), as she breaks ice in the Milwaukee River. (Date of photograph: February 1936; photographer: unidentified.)

The tug *Conrad Starke* is towing an unidentified coal carrier between the Wisconsin Avenue and Wells Street Bridges. The First Wisconsin National Bank is on the left. (Date of photograph: unidentified; photographer: unidentified.)

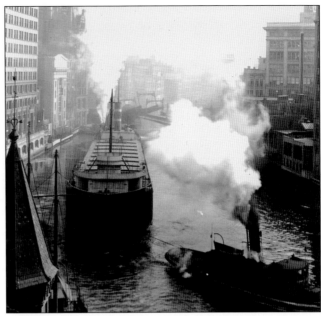

The coal vessel *Pegasus* is passing through the Wells Street Bridge. It was a tight fit but was workable with the aid of tugs. (Date of photograph: unidentified; photographer: unidentified.)

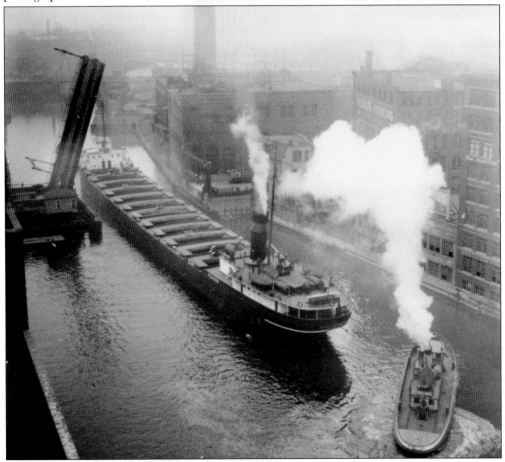

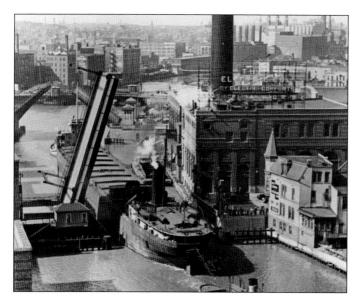

The freighter *Angeline* is being towed stern first through the Wells Street Bridge. She was one of the first three steamers to depart Milwaukee at the opening of navigation in 1937. The chimney is part of the Electric Company's Oneida Street Plant on East Wells Street. (Date of photograph: April 8, 1937; photographer: unidentified.)

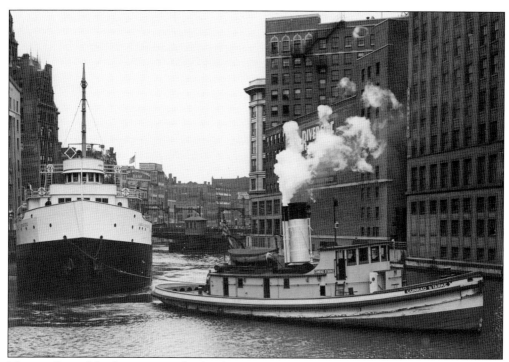

The tug *Conrad Starke* is towing the freighter *James McAlpine* on the Milwaukee River. Notice the Wisconsin Avenue bascule bridge in the background. (Date of photograph: March 23, 1939; photographer: unidentified.)

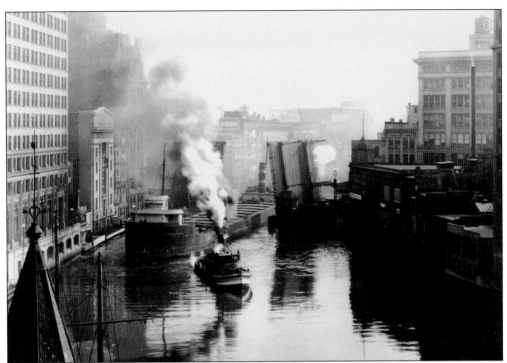

Looking south, an unidentified coal vessel is being guided by the tug *Conrad Starke* through the Wisconsin Avenue bascule bridge. (Date of photograph: unidentified; photographer: Kaiser.)

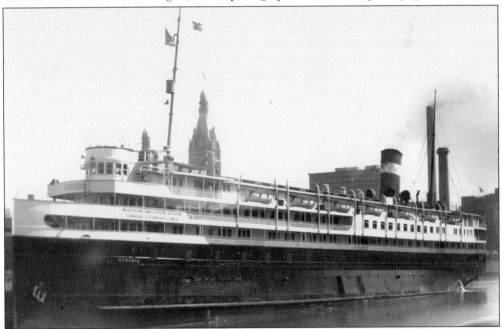

Canada Steamship Lines flagship *Noronic is* moored in the Milwaukee River for the American Legion convention of 1941. City hall is towering above her. In 1949, the ship burned at her dock in Toronto, with a considerable loss of life. (Date of photograph: September 14–18, 1941; photographer: August Riemenschneider.)

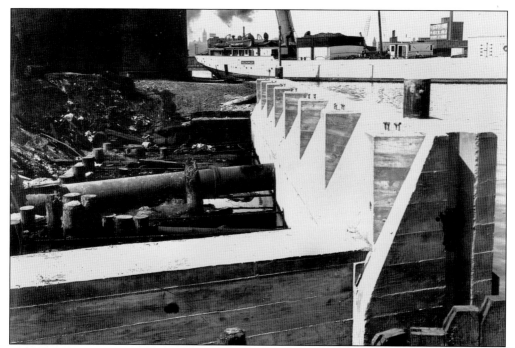

The Park Street dock on the Milwaukee River is seen here undergoing construction. Across the river is the steel package freighter *P. E. Crowley* of the Western Transit Company. (Date of photograph: unidentified; photographer: unidentified.)

The schooner yacht *Atlantic* is moored at the Schlitz Brewing Company dock on the upper Milwaukee River, with the Commerce Street Power Plant on the left. (Date of photograph: June 1952; photographer: Capt. John Blank.)

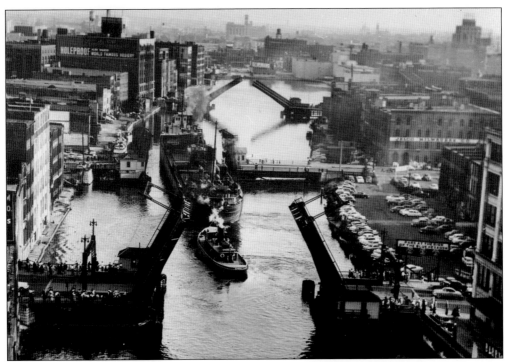

The steamer *C. W. Richardson* is being towed through the Clybourn Street Bridge by the tug *Roger*. So long as there were lift bridges remaining, larger vessels could still trade up the river. (Date of photograph: August 1953; photographer: unidentified.)

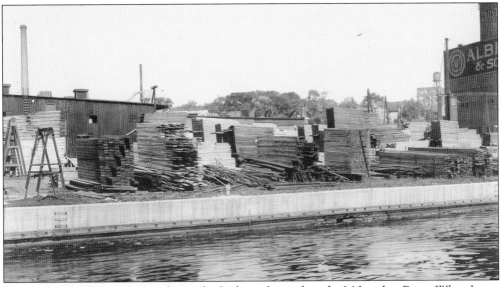

This is the John Schroeder Lumberyard, which was located on the Milwaukee River. When larger vessels could no longer come up the river, it created supply problems for businesses such as this. (Date of photograph: unidentified; photographer: unidentified.)

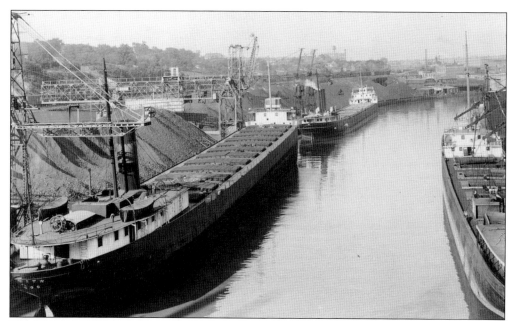

The Milwaukee Western Fuel Company was located on the Milwaukee River, above the Holton Street Viaduct. Vessels such as these can no longer traverse the Milwaukee River north of its junction with the Menomonee. (Date of photograph: unidentified; photographer: unidentified.)

This is looking south at the Michigan Street Bridge in 1964. Notice that the trolley catenary is still in place, although the trolleys themselves are long gone. (Date of photograph: 1964; photographer: unidentified.)

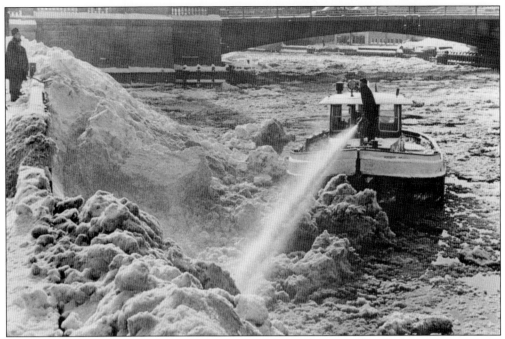

Harbor Master Swinford uses a hose aboard the M/V *Harbor Seagull* to flush snow away at the snow dump in the Milwaukee River. The practice of dumping snow into the river has been discontinued. (Date of photograph: 1965; photographer: unidentified.)

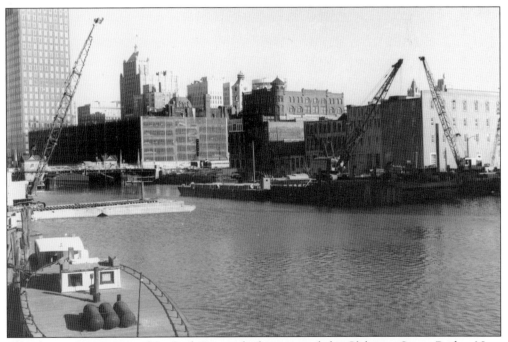

This shows construction of St. Paul Avenue looking toward the Clybourn Street Bridge. Note the fish tug in the lower left. Commercial fishing in Milwaukee has diminished over the years and continues to decline. (Date of photograph: November 5, 1966; photographer: unidentified.)

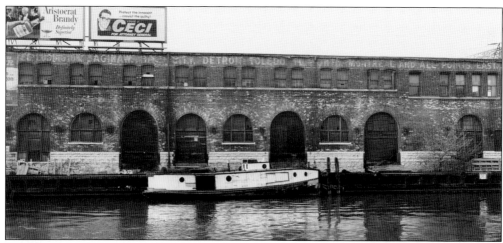

A fish tug is tied up at a private wall dock on the Milwaukee River north of Buffalo Street. (Date of photograph: November 16, 1966; photographer: unidentified.)

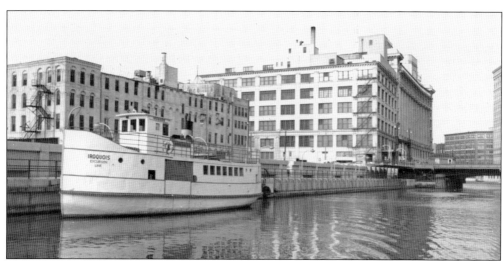

Excursion vessel *Iroquois* is shown at the city dock, just south of the Michigan Street Bridge. (Date of photograph: November 15, 1966; photographer: unidentified.)

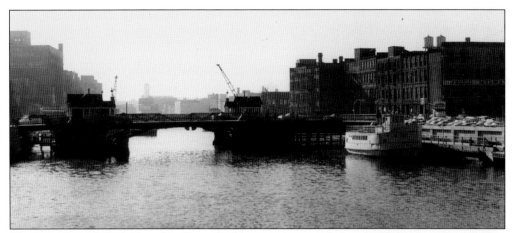

This is a shot of the Milwaukee River looking south toward the old Clybourn Street Bridge. The excursion vessel *Iroquois* is tied up on the right. (Date of photograph: November 5, 1966; photographer: unidentified.)

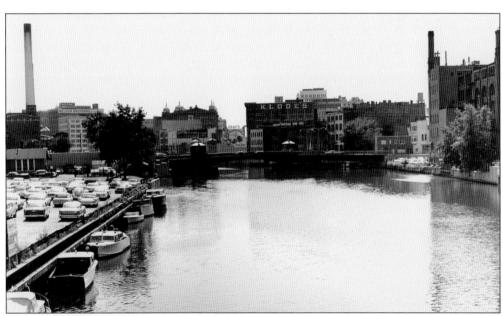

The Blatz Brewing Company dock on the Milwaukee River is seen here located south of Juneau Avenue. Note the private powerboats tied up. (Date of photograph: August 3, 1964; photographer: Milwaukee Public Library.)

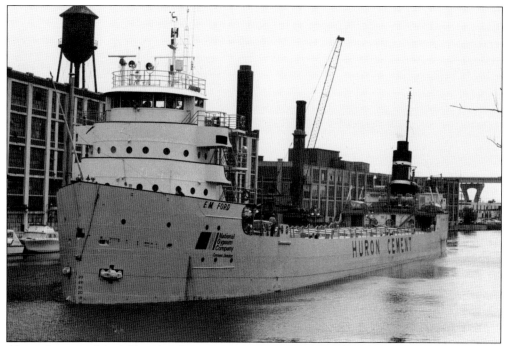

Along the stem of the Milwaukee River, cement carrier *E. M. Ford* is passing warehouses that are condominiums today. The Hoan Bridge is visible in the background. (Date of photograph: May 1981; photographer: Robert W. Brown.)

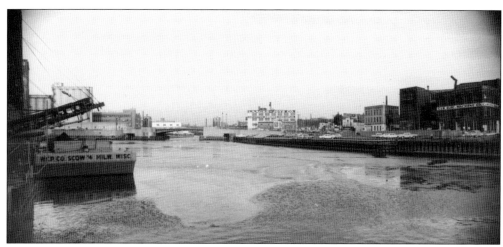

The Milwaukee River is pictured upstream from McKinley Avenue. Other than the Wisconsin Electric Power Company's scow, there is not much waterborne commerce in evidence. (Date of photograph: November 15, 1966; photographer: unidentified.)

Six
THE PORT OF MILWAUKEE TODAY

Vessel traffic in the Menomonee and Milwaukee Rivers has pretty much disappeared, but the Kinnickinnic and especially the inner harbor have remained busy. Bulk cargos, of such things as road salt, cement, and coal, have been the port's mainstay and continue to be shipped in and out of the port in tremendous quantities. The ships that carry these materials today, both in Milwaukee and throughout the Great Lakes, are either self-unloaders or articulated tug/barge combinations, and they arrive and depart with regularity.

The one active grain elevator, the Nidera, is still shipping corn and other grains. In recent years, large quantities of grain have been shipped through the Illinois Waterway by barge, but Canadian and saltwater vessels still haul much of it.

The inner harbor also continues to be used by steamship companies to store their vessels over the winter layup, although their number appears to be limited to only two or three 1,000-foot carriers, and some cement boats, rather than whole fleets as there were in the past.

The outer harbor receives the general cargo, such as machinery and steel, with much of it arriving in foreign vessels traveling the Great Lakes. Some bulk cargos like road salt also arrive in the outer harbor. The liquid-cargo terminal is still used to some degree. There are plans to update and refurbish it, which means the quantities it handles will probably be increasing.

Nearly every year, the volume of goods passing through the Port of Milwaukee has increased, so what looks like less vessel traffic is more than made up for by the increased size of the ships themselves.

For those who are interested, the best place to observe vessel traffic in the outer harbor is the Lakeshore State Park, particularly from the red pierhead lighthouse. The small park at the end of Greenfield Avenue is best for the inner harbor. Parking is limited at both locations, but both are readily accessible.

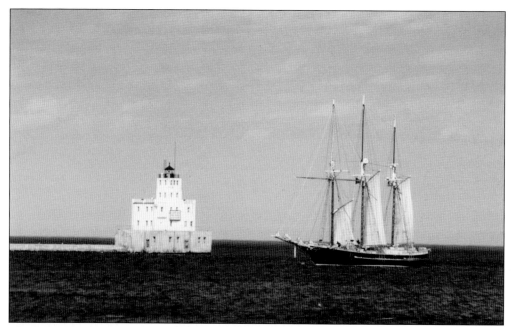

The schooner *Denis Sullivan* passes the breakwater lighthouse on an afternoon excursion cruise of the harbor. The *Sullivan* is a full-size reproduction of a 19th-century schooner. She was built in Milwaukee in 2000. (Date of photograph: July 31, 2007; photographer: Charles A. Sterba.)

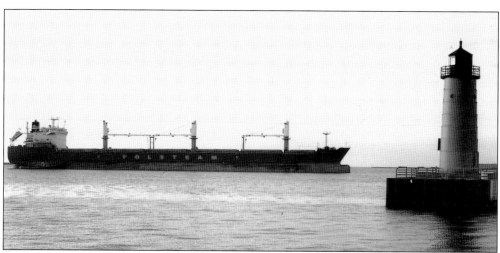

The Polish Steamship Lines *Isadora*, assisted by Great Lakes Towing's tug *Arkansas*, is arriving in the outer harbor, probably with a cargo of steel. (Date of photograph: July 3, 3007; photographer: Charles A. Sterba.)

Kadinger Marine's tug, *Ruffy J. Kadinger*, is tied up under the Hoan Bridge while the crew has lunch. The *Ruffy J.* no longer works out of Milwaukee. (Date of photograph: March 29, 2001; photographer: Charles A. Sterba.)

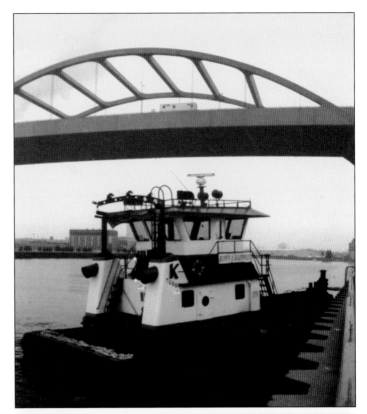

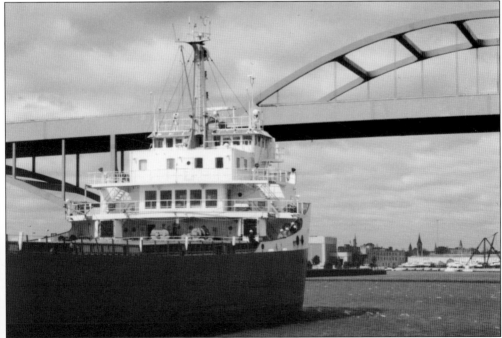

The Canadian self-unloader *Algosteel* is arriving in Milwaukee, probably with a cargo of road salt. (Date of photograph: May 13, 2000; photographer: Charles A. Sterba.)

Canadian self-unloader *Algorail* arrives in port, just as the sun is going down. She will head over to the salt dock, discharge her cargo, and be gone with the morning light. (Date of photograph: October 12, 2000; photographer: Charles A. Sterba.)

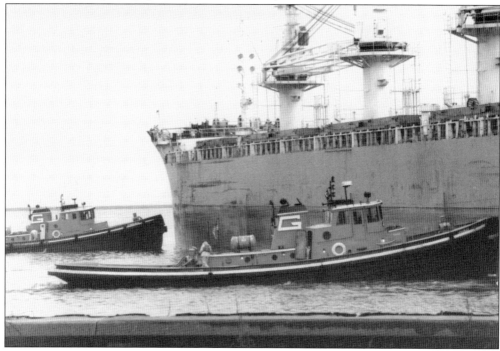

The Great Lakes Towing Company's tugs *Virginia* and *Arkansas* assist the saltwater vessel *Marilis T.* into her dock in the outer harbor. (Date of photograph: November 16, 2000; photographer: Charles A. Sterba.)

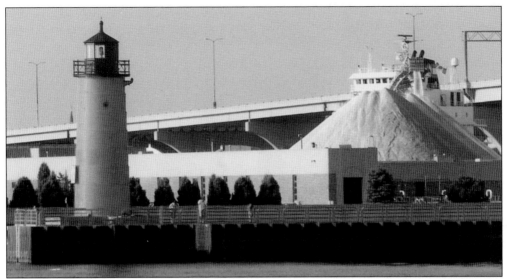

The pierhead light and Interstate 794 frame the *Peter R. Cresswell* as she unloads salt in the outer harbor on a warm summer morning. (Date of photograph: August 17, 2008; photographer: Charles A. Sterba.)

Saltwater vessel *Prabhu Daya* is tied up at Terminal No. 1. Beyond the elevated structure of Interstate 794, some of the other port transfer sheds are visible. (Date of photograph: August 21, 1998; photographer: Charles A. Sterba.)

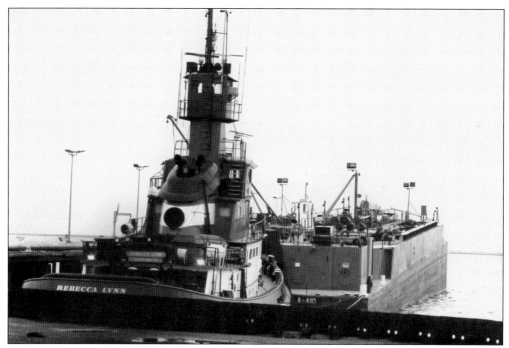

Andrie, Inc., tug *Rebecca Lynn* and tank barge A-410 are at the liquid cargos dock, stern to the shore, as they unload their cargo. (Date of photograph: January 28, 2006; photographer: Charles A. Sterba.)

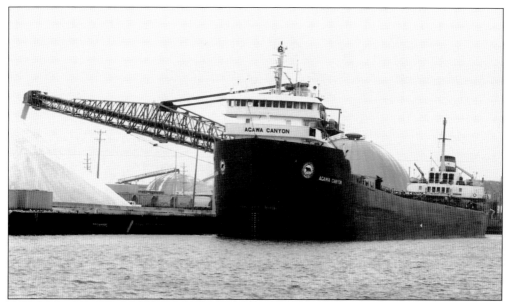

Canadian self-unloader *Agawa Canyon* is discharging her load of road salt to a pile in the inner harbor. (Date of photograph: October 2, 2007; photographer: Charles A. Sterba.)

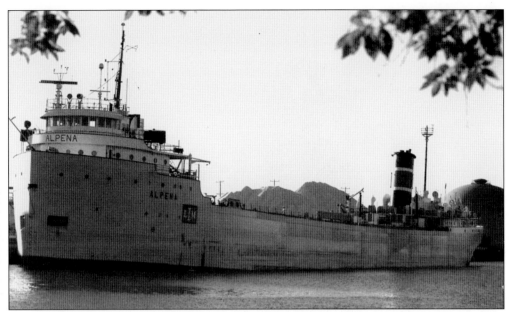

Inland Lakes Management's *Alpena* is waiting at the LaFarge Cement dock in the inner harbor to discharge her cargo. The *Alpena* was built as the bulk freighter *Leon Fraser* in 1941 and was later cut down to a cement carrier in 1991. (Date of photograph: August 15, 2006; photographer: Charles A. Sterba.)

University of Wisconsin-Milwaukee's Great Lakes Water Institute operates the research vessel *Neeskay*, which is seen here in the inner harbor passing the Allen-Bradley Clock Tower. The clock tower is popularly known as "the Polish moon" because of its size and brightness. (Date of photograph: July 15, 2008; photographer: Charles A. Sterba.)

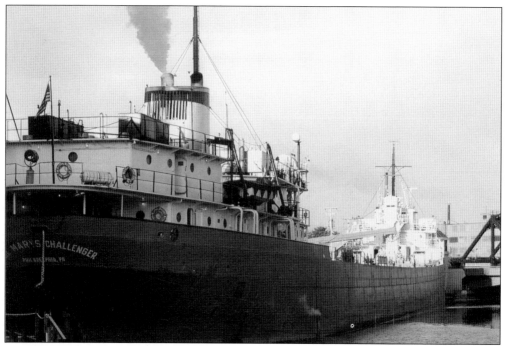

The cement carrier *St. Marys Challenger* docks far up the Kinnickinnic River at the Kinnickinnic Avenue Bridge. She is a regular visitor to the Port of Milwaukee. (Date of photograph: June 19, 2007; photographer: Charles A. Sterba.)

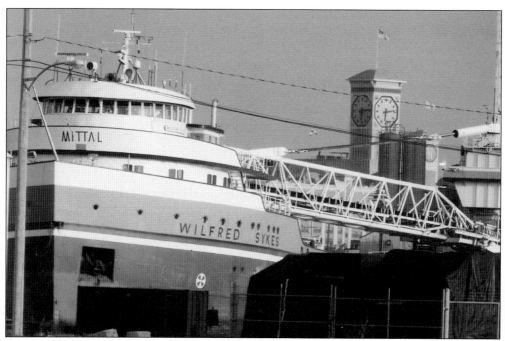

Wilfred Sykes is at the extreme southern end of the inner harbor basin discharging a cargo of cement clinker. The Allen-Bradley Clock Tower is visible behind her. (Date of photograph: July 10, 2007; photographer: Charles A. Sterba.)

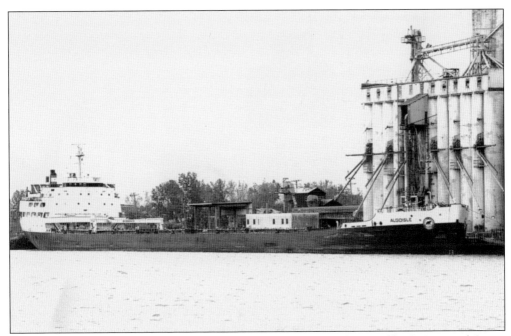

The *Algoisle* is under the spouts at the Nidera grain elevator, formerly owned by Continental Grain. She is taking on a cargo of corn that is bound for a Canadian port, where it might be transshipped to Europe. (Date of photograph: October 11, 2007; photographer: Charles A. Sterba.)

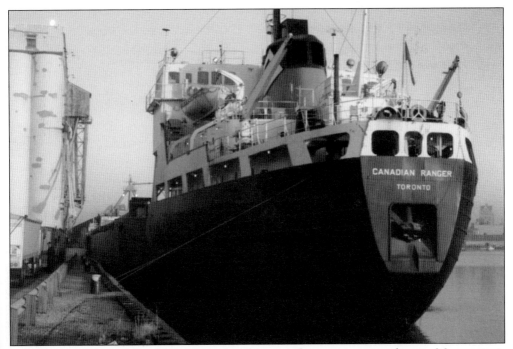

In this view, the *Canadian Ranger* is at the elevator taking on a cargo of grain. Most grain is shipped out of Milwaukee in Canadian or saltwater ships. (Date of photograph: October 19, 2000; photographer: Charles A. Sterba.)

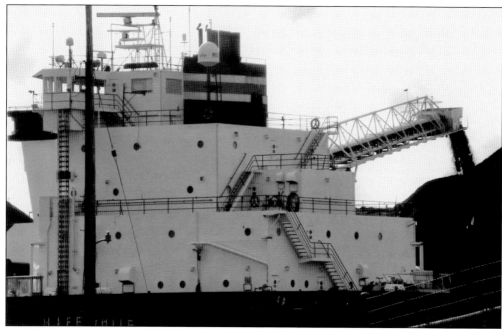

The *H. Lee White* discharges her coal load at the coal dock at Greenfield Avenue and the inner harbor. Coal is then loaded on barges and brought to the Wisconsin Electric Plant up the Menomonee River. Large lake carriers no longer go beyond the inner harbor. (Date of photograph: October 6, 2009; photographer: Charles A. Sterba.)

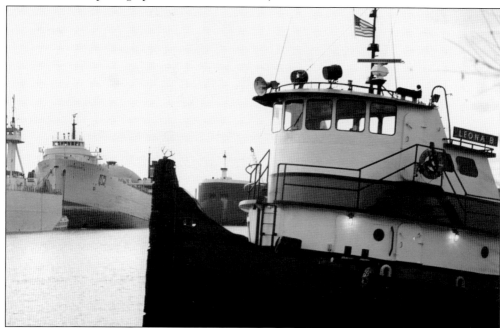

Here the tug *Leona B.* passes the *Intergrity*, the *G. L. Ostrander*, the *A. J. W. Iglehart*, and the *Burns* to retrieve an empty coal barge. This transshipment of coal from the inner harbor to the Menomonee is handled by the *Leona B.* (Date of photograph: February 28, 2008; photographer: Charles A. Sterba.)

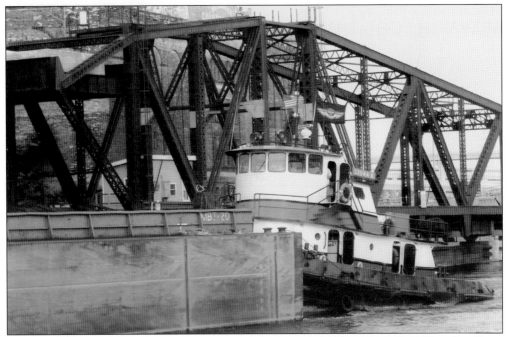

The *Leona B.* is pushing her coal barges out of the Menomonee and into the Milwaukee River and is heading for the inner harbor. The old swing bridge still operates and is used by trains of Amtrak's Hiawatha Service between Chicago and Milwaukee. (Date of photograph: August 26, 2008; photographer: Charles A. Sterba.)

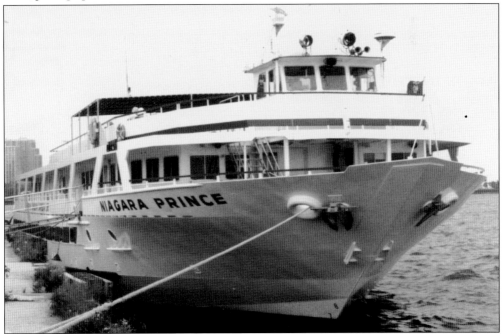

Passenger vessels do still call in Milwaukee, although their number is far below those of the past. Here the *Niagara Prince* is tied up at the passenger terminal, where the *Denis Sullivan* docks, near Discovery World at Pier Wisconsin. (Date of photograph: August 25, 2000; photographer: Charles A. Sterba.)

www.arcadiapublishing.com

Discover books about the town where you grew up, the cities where your friends and families live, the town where your parents met, or even that retirement spot you've been dreaming about. Our Web site provides history lovers with exclusive deals, advanced notification about new titles, e-mail alerts of author events, and much more.

MADE IN THE USA

Arcadia Publishing, the leading local history publisher in the United States, is committed to making history accessible and meaningful through publishing books that celebrate and preserve the heritage of America's people and places. Consistent with our mission to preserve history on a local level, this book was printed in South Carolina on American-made paper and manufactured entirely in the United States.

This book carries the accredited Forest Stewardship Council (FSC) label and is printed on 100 percent FSC-certified paper. Products carrying the FSC label are independently certified to assure consumers that they come from forests that are managed to meet the social, economic, and ecological needs of present and future generations.

FSC
Mixed Sources
Product group from well-managed forests and other controlled sources

Cert no. SW-COC-001530
www.fsc.org
© 1996 Forest Stewardship Council

Find Your Place in History.